The Human Face of Climate Change

The human Face
of
Climate Change

Mathias Braschler
Monika Fischer

With texts by Jonathan Watts

**HATJE
CANTZ**

Contents

The Human Face of Climate Change

Jonathan Watts

Seven billion people. Nine gigatons of carbon dioxide emitted annually. A global temperature rise of 0.7 degrees over the past century. When we try to comprehend the threat posed by climate change, it is usually with a barrage of such statistics, which can terrify, confuse, and alienate. But in these pages, Mathias Braschler and Monika Fischer achieve something far more important: they put a human face on the existential challenge facing our species—and, in doing so, make it tangible, intimate, and immediate.

This series of portraits and personal stories is the result of a photojournalistic odyssey around the globe, photographing and interviewing those on the frontline of change. The experiences of the subjects vary as spectacularly as the landscapes. For Chai Erquan, it is the dust storms and desert sands that creep ever closer to his crops in northern China. For Karotu Tekita, it is the sea that is steadily eroding the South Pacific atoll he calls home. For elderly Inuvialuit trapper Billy Jacobson, it is the increasing danger of air holes in the warming polar ice. For the nomadic herder Abdallay Abdou Hassin, it is the stench of death that haunts his family in the intensifying furnace that is drying up Lake Chad.

The photographers' epic journey started in Australia on February 7, 2009, one of the hottest days in that country's history and soon to be followed by a bushfire in Victoria that killed more than two hundred people. Their travels ended eight months later in Canada, where they took portraits of Inuvialuit who were seeing the frozen earth melt beneath their feet, and Cuba, where locals were trying to rebuild lives wrecked by the ferocious back-to-back hurricanes that had struck the country the previous year.

In between, they climbed the Peruvian Andes to photograph llama herders who fear the shift in the seasons is destroying their livelihoods; drove out to dried-up lakes near Timbuktu, where Bozo fishermen are losing their only source of income; and boated out to the edge of Bangladesh's Sunderbans National Park, where increasing numbers of villagers are being eaten by tigers because the flooding of paddies forces residents to venture more often into the jungle to find food.

For the photographic team, the climate portraits are the latest in a series of increasingly ambitious projects inspired by international events. Before the 2006 World Cup, they photographed David Beckham, Zinédine Zidane, Cristiano Ronaldo, and other soccer stars a minute after full-time. Before the 2008 Beijing Olympics, they drove across China for six months, shooting portraits of farmers, tycoons, beggars, prostitutes, and others living through a period of super-accelerated development. But the scale of those undertakings paled in comparison to this latest work.

"We have decided to make things a bit more complicated this time," Mathias Braschler noted with marked understatement at the outset of a journey that was to cover sixteen nations and every continent and sort of terrain, ranging from mountain glacier and ice cap to flood plain and forest.

Climate change tends to accelerate and intensify existing patterns, rather than create new phenomena. There are almost always other factors at play. This is not the only reason why it is difficult for writers and photojournalists to report on the subject. The modern twenty-four-hour news media likes issues to be clear-cut, visually strong, and fast-moving. Global warming is anything but. The science is evolving, the cause is invisible, and the pace is incremental. But Braschler and Fischer were undeterred. With their pioneering approach—an eight-month project using medium and large-format cameras with studio lighting plus video and audio recordings—they felt they could go beyond the scope of conventional media.

I caught up with them in Thailand, where we found ourselves speeding through mangrove swamps on long-tailed boats on the hottest day of the year. "We used to consider thirty-five degrees Celsius the peak of summer, but now the temperature is often above forty," our guide observed as we made our way to Kun Samut, a poor fishing village near Bangkok that was fighting a losing battle against the elements.

The wetland teemed with wildlife—mudskippers slithered across the fish ponds, herons perched on the rails outside the thatched houses, and cranes flapped back and forth across the dull gray skies. But nature had become increasingly inhospitable. The sudden rise in temperature had decimated shellfish farms and the catches of fishermen.

"The climate used to follow natural patterns. But now the storm patterns are disrupted and the rains no longer come at the right season," said Wanee Mainuam, a fisherwoman, in a refrain that was to be echoed again and again by the subjects of the project.

One of the most pressing effects of climate change is the increase in extreme weather events, such as droughts, floods, and typhoons. For some of Braschler and Fischer's subjects, such as the Italian farmers who lost part of their crops to freak hailstorms that rained down jagged ice stones, killing birds and decimating plants, this was a costly inconvenience. For the more vulnerable, it could cause crippling poverty or death. The photographers saw this in India, where the unusual flash floods in the mountains of Ladakh destroyed homes and crops; in Bangladesh, where the encroachment of saline water during storms was driving countless people from the delta into the slums of Dhaka; and near Lake Chad, where prolonged drought had shrunk the lake, devastated herds, and increased the number of deaths caused by starvation and filthy water.

To get such stories, Braschler and Fischer endured bacterial infections, car breakdowns, spider bites, mosquito swarms, altitude sickness, desert heat, and arctic cold on their journeys. Perhaps the toughest obstacle they encountered, however, was skepticism.

Anthropomorphic climate change is accepted by the vast majority of the world's governments

and climatologists, but so much is at stake that it remains the subject of a fierce debate fought with a semi-religious passion and billions of dollars of funding from the fossil-fuel industry. In some areas, every problem is blamed on global warming. In others, it is either denied or considered a blessing. This was most evident in the vastness of Siberia, where the capital city of Russia's Sakha Republic, Yakutsk—the world's largest city on ice—appeared divided on whether global warming had brought the best or worst of times.

We arrived on an aging Tupelov jet soon after midsummer, when this city—just south of the Arctic Circle—enjoys "white nights" of sunlight. Yakutsk is a land of extremes. In winter, the mercury can plunge below minus sixty-five degrees Celcius. In summer, it climbs to over thirty. In recent years, however, the winters have become shorter and warmer. Since the 1960s, temperatures have risen by more than two degrees—one of the fastest rates on the planet. Reports from the region suggested that the thick layer of permafrost on which the city is built was melting.

Even so, at our first port of call—the Permafrost Research Institute in Yakutsk—scientists insisted that the change was minimal. Deputy director of the institute Mikhail Grigorieve speculated that the rising temperatures were part of a natural climatic cycle that had little impact on the seventy-meter-thick layer of subterranean ice. To prove his point, he took us underground to see chambers of ice lying just a few meters below the surface. "We don't see dramatic changes. But climate change hasn't been going on for long. The effect may be more dramatic in the future," he said.

Elsewhere, however, there were signs of subsidence in cracked and distorted roads, tilted telephone poles, and several dozen alarmingly buckled old buildings. Local officials showed us pictures of what they said were worsening annual floods; activists told us the melt was accelerating; and, in the city, we talked with and photographed residents whose homes were perilously close to collapsing.

"We have many floods in this house, especially in spring, when the ice melts and all the water comes into the house, and that is why the floor of the house is so high," said Valery Nikolaevitch, a retired Cossack living in a building where the floor has had to be raised so many times that the residents looked like giants in a doll's house. "Maybe it's due to climate change," he said, before his wife cut him short with a curt contradiction that they faced no problems with melting permafrost and the problems had more to do with the bad drainage of a nearby road.

They could both have been right. The geophysicist Vladimir Federov Romanovsk said the permafrost was slowly melting, and in areas near roads and construction sites, where the insulating surface of grass has been damaged, it was melting fast enough to undermine buildings. There were others signs of change. Vladimir Vasiliev, an ecologist at the Northern Forum Academy, told us meltwater floods were becoming more frequent, forests were more prone to disease, and reindeer pastures were disappearing. Siberia was feeling the heat and so were many other places.

I received regular updates of Braschler and Fischer's progress, including disturbing

stories of shrinking polar ice, worsening forest fires, intensifying hurricanes, retreating glaciers, and sudden, unseasonal shifts in temperature—all related firsthand by the subjects of these portraits.

Not surprisingly, anxiety is evident on many faces. Rising temperatures are evaporating more water and charging the atmosphere with more energy, creating increasingly unpredictable and extreme weather events. Add the over-use of water resources, the mismanagement of forests, soil degradation, and pollution, and it becomes clear that human activity is changing our world and its climate, mostly for the worst.

On their expeditions, Braschler and Fischer heard a variety of opinions ranging from "The end is near" to "Climate change is media hype." They encountered cases where global warming was being dubiously used as an excuse to make money and other instances where the climate was given as an overly simplistic explanation for environmental problems that also had a great deal to do with population pressure, poor water management, or excessively industrialized agriculture. But the photographers said they came away more convinced than ever that global warming was a dangerous reality and its effect was intensifying. "Once you go out there you can really see what an impact it can have. It's changing people's lifestyles, changing people's traditions. It's already hitting the poor, the people who lead subsistence lifestyles," Monika Fischer said.

Just as there is an economic gap in populations, there is also a climate gap. The people making decisions about carbon emissions tend to be wealthy urbanites living air-conditioned lives. Those who are directly affected by climate change, on the other hand, are more likely to be poor and exposed to life on the environmental edge, near encroaching deserts, flooded riverbanks, eroded coastlines, and melting glaciers. Disproportionately, these individuals are members of ethnic minorities.

After completing their epic project, the photographers believe it is only a matter of time before rich city dwellers begin to feel the impact. "With our lifestyles, you don't really see that much or it's easier to adapt. But I am quite certain that this will change. We are going to see changes coming to our cities, and it will affect all of our lives," Braschler says. "It is a real threat. It is a real problem. And we should definitely do something about it."

Jonathan Watts is *The Guardian's* Asia environment correspondent.

ASIA / RUSSIA

Bangladesh

India

China

Thailand

Russia

Bangladesh

Hosnaara Khatun (22) and her son, Chassan (1)
"Tiger Widow"
Sora, Gabura, Bangladesh

Seven days ago, a tiger killed my husband when he went to
the Sundarbans to collect honey. We all cried when we heard
the news. He knew it was dangerous but he had to go or our
family would starve. If it were possible to do paddy farming
or fish cultivation, then he wouldn't have had to enter the
national park illegally. Because of river erosion people have
to leave the village to earn money. We fear flooding. There
is more salt in our water. I think climate change has
something to do with that. Our biggest problem is poverty.
Life is very hard here. People cannot eat three meals a
day. In the future, my children may also have to go to the
Sundarbans to make money. They will face the same danger as my
husband. But now that we cannot cultivate rice or vegetables,
there is no other way to
survive.

Gabura is part of a wide swath of southern Bangladesh that suffers from
floods, the intrusion of saltwater from the sea into freshwater rivers
and ponds, and erosion as a result of rising sea levels and increased
storm activity.

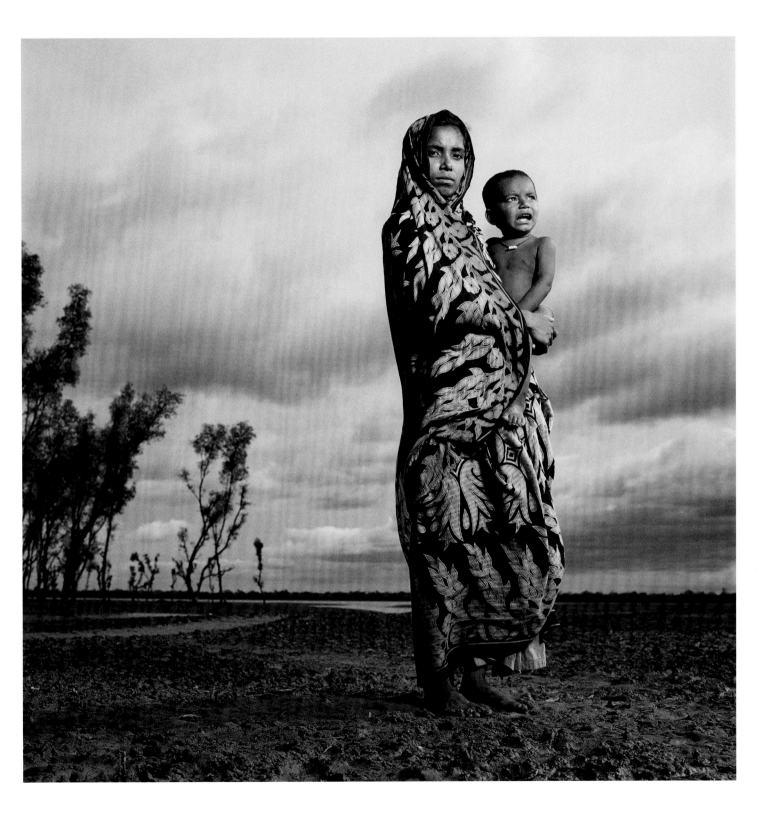

Bangladesh

Hamida Khatun (35) and her daughter, Fatima (10), in front
of their destroyed house
Day laborer / Victims of recent flood
Saliakhali, Gabura, Bangladesh

My house was destroyed by the storm a couple of months ago.
The cyclone broke the riverbank and my house was flooded.
Everything was devastated. Now I sell my labor to other
farms or homes. The environment has changed. At full moon
the tides have risen. The river is spreading wider. I am
scared for my daughter because of the river erosion and the
saltwater intrusion. If the problem goes on like this, it
will be very bad for her.

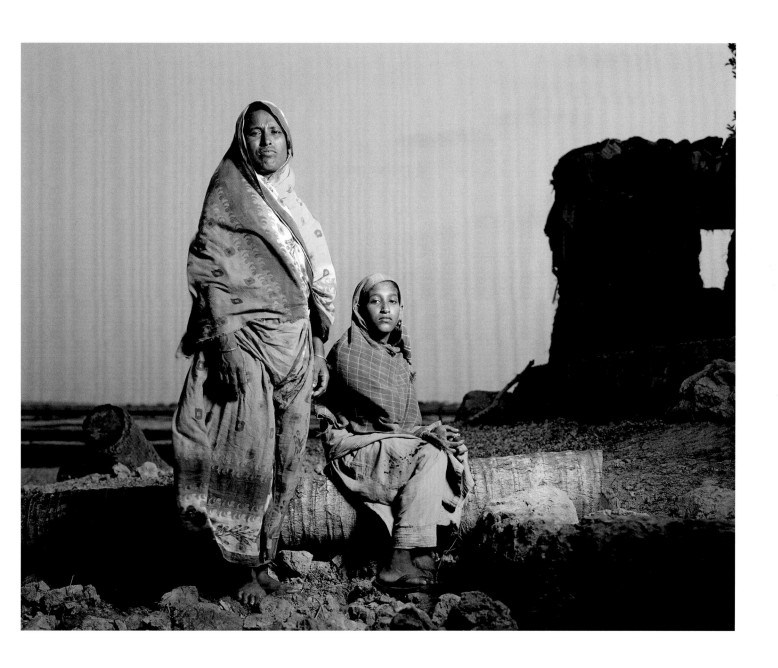

Bangladesh

Azizul Islam (50), helping to repair a broken embankment
Day laborer
Chadnimukha, Gabura, Bangladesh

I am here to repair this embankment. It often breaks because
the river erodes the soil. It has broken twice in the past
year and each time there is devastation. We have lost
our drinking water, our trees, our houses. We have lost
everything to the river. Our houses are made of mud. They
collapse when it floods and we have to rebuild them again.
So much has changed in the last twenty years. There are no
trees because they don't grow well in salty water; neither
do rice paddies. When I was a child, Gabura was a very
beautiful place but now it has changed. Now there are no
cattle, no grass, no fish to eat. These things are happening
because the water level is rising. Salt water is flooding
the land. The plants cannot grow. Our green country is
changing color. I cannot stay. Our island, Gabura, will be
flooded in eight to ten years, so I am thinking I should go
elsewhere to make a living.

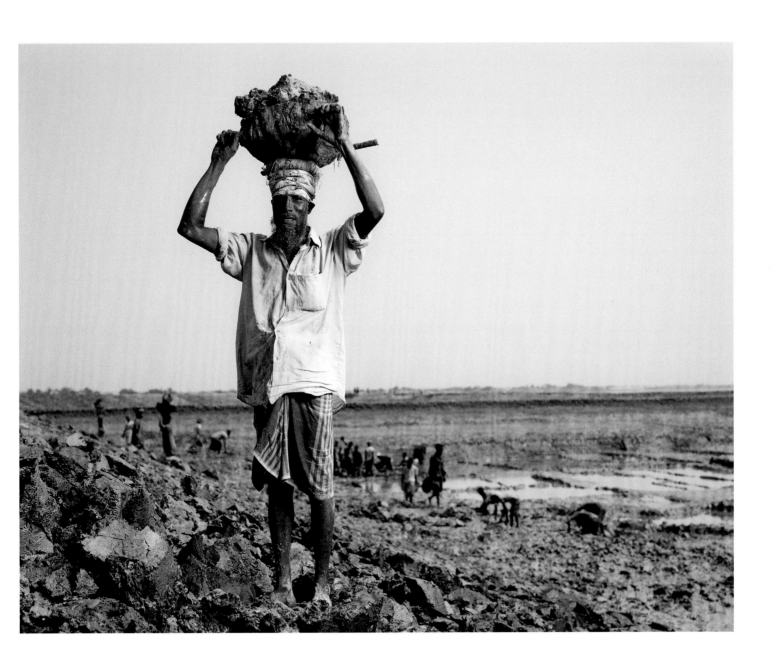

Bangladesh

Monira Khatun (21) with her son, Jiaur (3)
Laborer
Moheshora, Gabura, Bangladesh

Some days we can eat, other days we can't. Our children are
hungry. We have no way to make a living. It was different
ten years ago. We had no problems then. But they are growing
day by day. The tides are getting higher, the embankments
are collapsing, and the weather is warming. Floods are more
frequent. Our paddy fields have been washed away and the
shrimp farms are suffering. There is no steady income. My
husband left a few months ago. He told me he was going to
Dumuria to cut the crops. He went because he could not earn
anything here. He was unable to feed and clothe us. I get
jobs sometimes in the salt factory, working in people's
houses, or maintaining the shrimp farm, but I live hand-to-
mouth.

When I was young, Gabura was a good place. People cultivated
rice in the field, and there were vegetables. But now the
water is saline so vegetables and trees cannot grow. The land
is no longer productive so people are making shrimp farms.
I will have to move to a place where I can survive and get a
job, but I don't know where that might be.

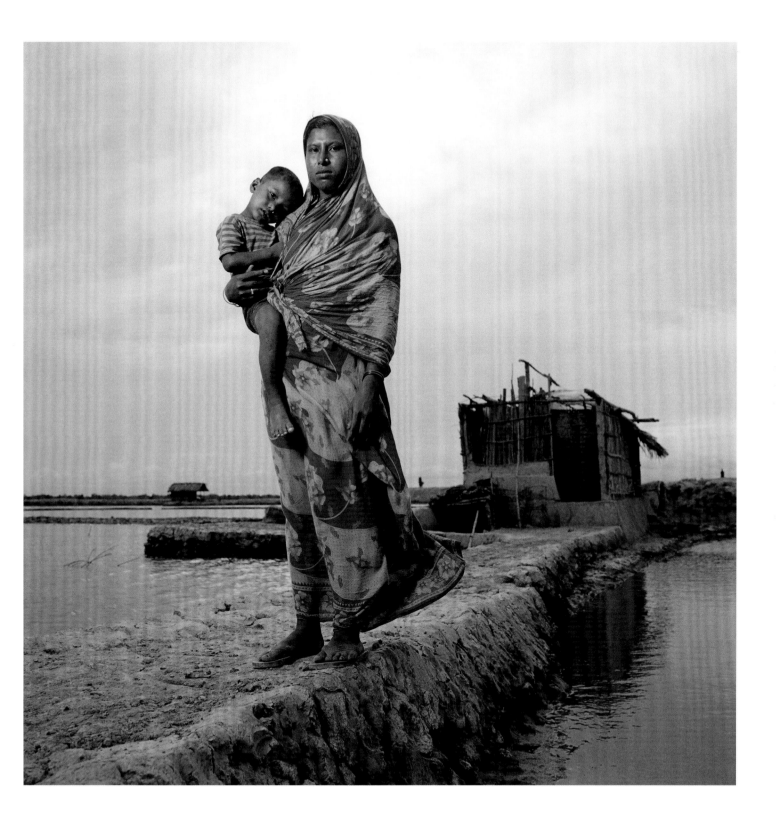

Bangladesh

Amena Khatun (70 to 80 years old)
Slum dweller
Barkater Slum, Dhaka, Bangladesh

We have moved three times since our home was washed away.
People put us up, but you cannot live in someone else's
house forever. That is why my daughter and I came to this
slum. Our old home was on the Meghna River in southern
Bangladesh. My parents were rich and I had a good marriage.
But I lost everything. That is Allah's will. The banks were
weakened by erosion and then the water level rose. It used
to happen slowly in the past. But it increased quickly.
All the trees and buildings slid into the river. Mango,
jackfruit, everything was submerged. When we arrived in the
slum, I cried a lot. My health is poor. It is hot and there
is not enough water or toilets. There used to be only a
few people here, but now there are too many. Most of them
were affected by the river. I fear for my daughter, my son,
and my grand children. How will they survive?

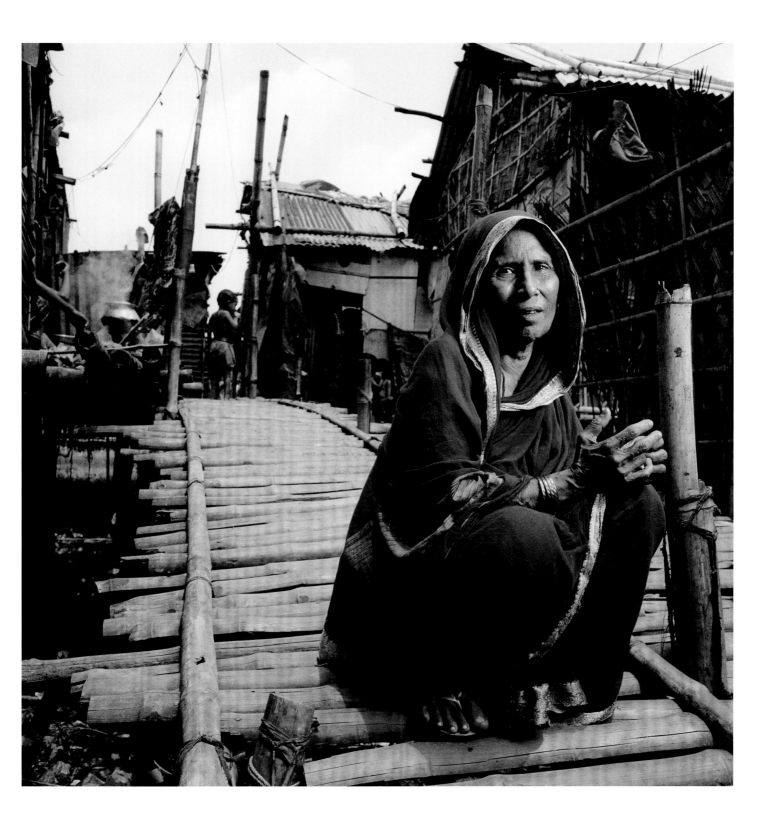

India

Rinchen Wangail (38), Phuntsok Amgmo (37), and their son,
Tsewang Tobjor (1)
Farmer
Nubra Valley, Ladakh, India

We lost our home in a flash flood in 2006. There had been
smaller floods before, but never anything like that. The
rains were massive. Fortunately, we managed to escape but our
house was destroyed. There was nothing we could do. A few
years ago, this was a very beautiful valley with plantations
and vegetation. But since the water came it is not the
same. Recently, we get a lot of rain in the winter, which is
unusual, and the snow is melting too much. In my life, I
have experienced flooding more than three times. Previous
generations never faced water problems like this. I feel sad
when I go to the spot where I used to have my house. There
is nothing left, except an apricot tree. In the new area we
do not have our own land and we can't do any farming, so it
is very sad for us. I fear a more dangerous flood will come in
the years ahead because the climate continues to change. I
would not be surprised if another flood comes and destroys
everything.

Ladakh is a cold desert in the Indian Himalaya, where farmers use meltwater
to irrigate their fields. A rise in temperatures has disrupted traditional
agricultural patterns and increased flash floods.

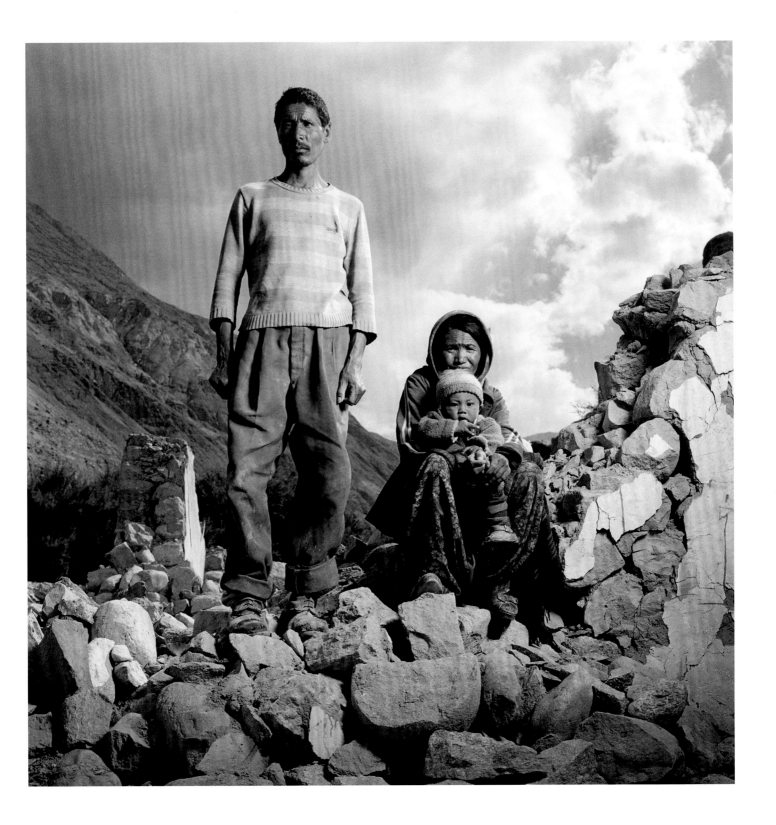

India

Tsering Tundup Chupko (51)
Farmer
Chemday, Ladakh, India

We have been good friends and neighbors for a long time in this village, but there have been some conflicts recently because of water shortages. We are going through some of the biggest changes I have experienced in my life. When I was a child, November, December, January, and February were extremely cold, and we had enough snow in our valley. Now, both summer and winter are almost the same. Every year there is less rain and the snow melts earlier. In summer, the glaciers melt, which causes floods that destroy fields, trees, plantations, and bridges. The valley also has a bigger population than in the past. This makes the water shortages more acute. Everybody feels something is going wrong. That is not good for us. We have a very effective water distribution system, but there is more abuse and bitterness about sharing. There is definitely more conflict. Many years back, a wise person said, "If there is no water, there is no valley." I think if this situation continues for more than twenty years, this valley will not survive.

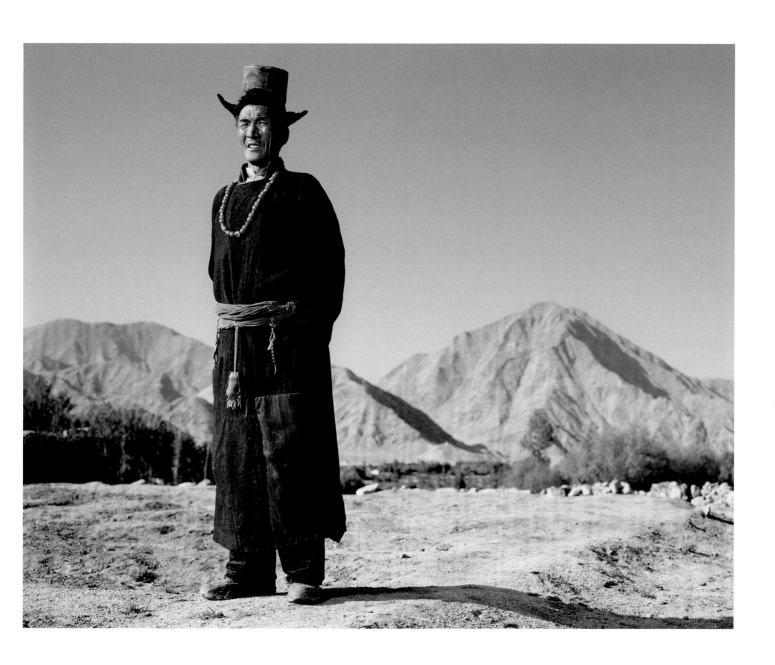

India

Padma Yangdol (36)
Flash flood victim
Phyang, Ladakh, India

We had just finished our new house when the flash flood came and destroyed everything. It was 10:30 at night. My family and I were asleep. All we could do was run to the mountains and watch helplessly. It was so sad. Our beautiful village was ruined. All the money my husband had earned in the army was invested in the home. We were just about to move in. That was three years ago. I'm still depressed. All the efforts of our ancestors were washed away. I have never experienced anything like it. Nor have my parents and grandparents. It is due to the change in the weather. The snow and rains are more unpredictable. It rains a lot. A new store was built in our village, but the deluge came again and it was destroyed. I am scared of the water now. When I recall that night, I can barely breathe. Now I live in a simple house further up on the mountain.

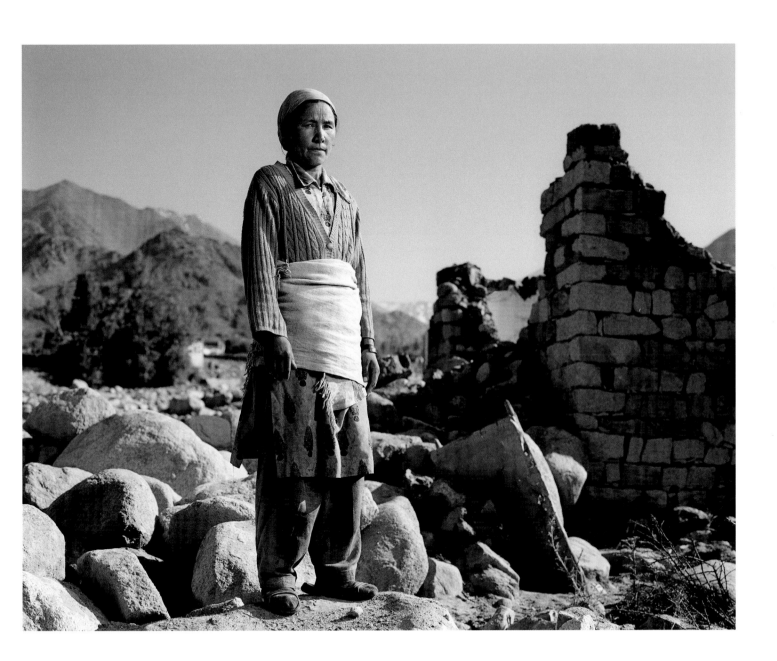

China

Chai Erquan (65)
Farmer / Shepherd
Hongsheng, Gansu, China

There are many sandstorms in this area. Sometimes they are
so bad that I can hardly see in front of my eyes and so the
sheep scatter everywhere. When I was little, we had a lot of
rain. We did not have any reservoirs, because we did not
need any. There was rain, water, and streams all around. But
now, we count on the irrigation pipes. I think it has been
getting hotter and hotter. In the nineties it got really bad.
Now we can barely raise sheep here. It has hardly rained at
all this year. Soon, I think this place will not have any
water left. Before, our wells only needed to be thirty to
forty meters deep. Today, we drill three hundred meters but the
water is still scarce. There is no drinking water left where
I live. You try very hard to get half a cup, maybe.

Gansu Province is in an area of northern China that has long been plagued
by desertification. Climate change in the form of rising temperatures and
accelerating evaporation rates is adding to these stresses, along with
increasing industrial and population demands for water.

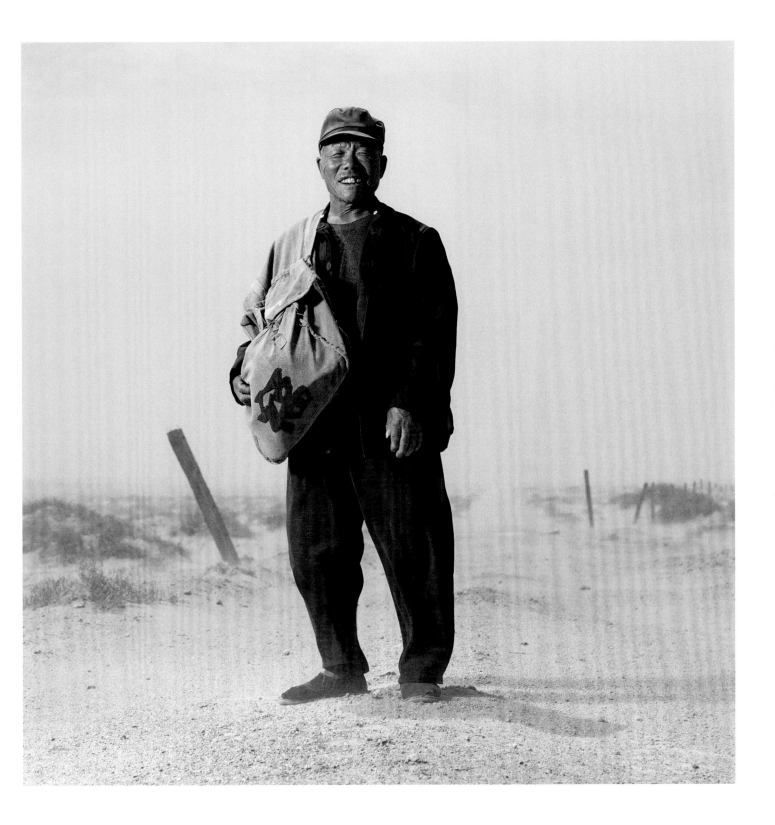

China

Wu Chunfeng (58)
Mahjong parlor employee
Liuzhou, Guangxi, China

We spent three days and two nights upstairs sheltering from the flood. This was the longest I have ever waited for the waters to subside. When I was younger, the floods came once every two years and were not as big as this one. But the last two years have been different. We have had them on consecutive years. That is rare. This time, the waters reached the third floor but normally they only come to the first or second floor. It is lucky the government informed us in time so that we were able to move our things.

I don't know about climate change but I know that our Earth is getting warmer. I can feel it is hotter and we have more rain in June, July, and August. But I am not worried. The floods follow nature's principles. During this time of year, we always prepare. The government built an embankment seven or eight years ago. Before that, the situation was worse. If the government hadn't built that, it would be an unbelievable disaster. The government and the local community will take care of us. They will inform us before the water comes. It will be OK.

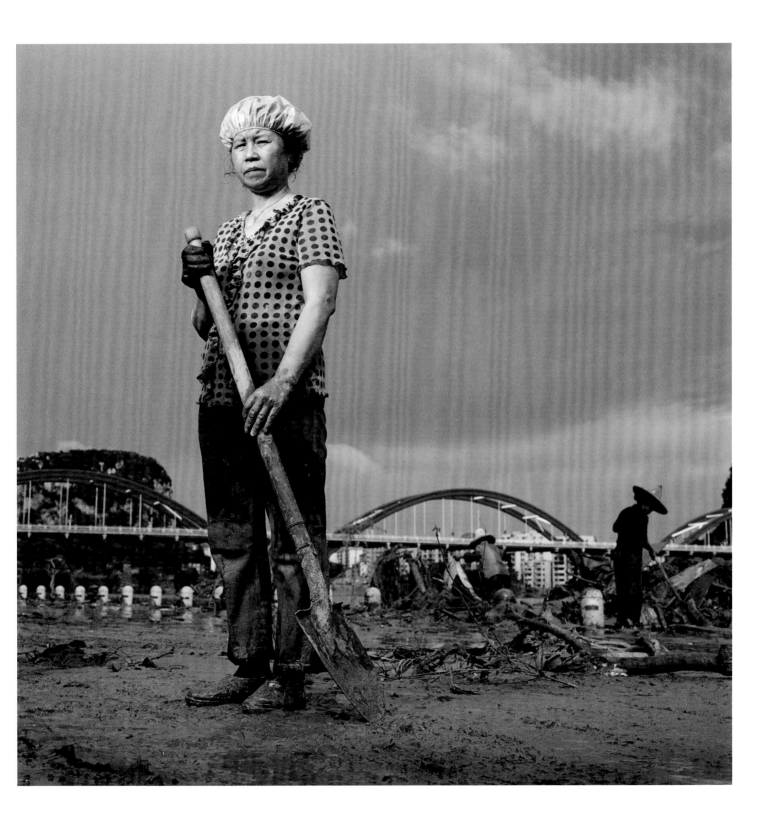

China

Yang Guorui (33)
Farmer
Huang'an, Gansu, China

We want to farm in this village but there is not enough
water and the sand is moving in. Personally speaking, I
think the situation is hopeless. We moved here three years
ago because it wasn't possible for us to live in our old
homes. When I was little, in the seventies and eighties,
there was already very little rainfall and it was very dry,
but it got worse and worse. We don't really understand
why. We decided to try our luck in this new place. It's not
really better but at least we have more land for farming. We
try to water the crops at least once every twenty or thirty
days but if there is no irrigation, they die. We plant
sunflowers because they are the most resilient in sandstorms,
but this year they are withering. We get a lot of sandstorms.
In the big ones, it feels like the dunes are moving. I'm
worried that the desert will encroach on our village. I
haven't just heard of climate change, I am experiencing it.
It is why this place will probably not be fit for human
habitation in the future.

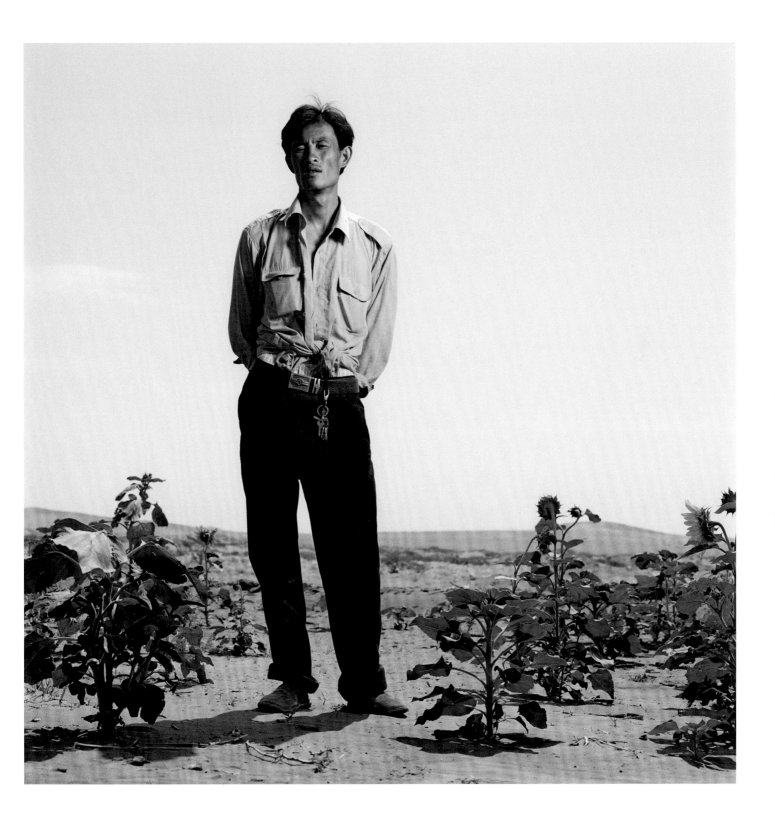

China

Yang Gengbao (69) and his wife, Huang Lianfeng (68), in front
of their home destroyed by flood
Shop owners and flood victims
Hongse, Guangxi, China

The rainstorms are heavier than those we had before. The
three biggest floods in my life have taken place over the last
twenty years. The latest was the worst after the ones in
1996 and 1988. The waters rose very quickly. Before we had
time to move anything, it was on our doorstep. When we
returned two days later, all our possessions had been soaked
or carried off by the waters. Our trinket shop is ruined, so
we have no income. Life has become tougher but we cannot do
anything. We just have to bear it. The floods always come
and even if they come more often, we will stay. We have been
here ten years. We don't actually like living here, but we
do it for survival. We need to make money for food. Where else
could we go?

Throughout history, the valleys and deltas of Southern China have been
buffeted by floods. In recent years, these have grown more frequent and
intense.

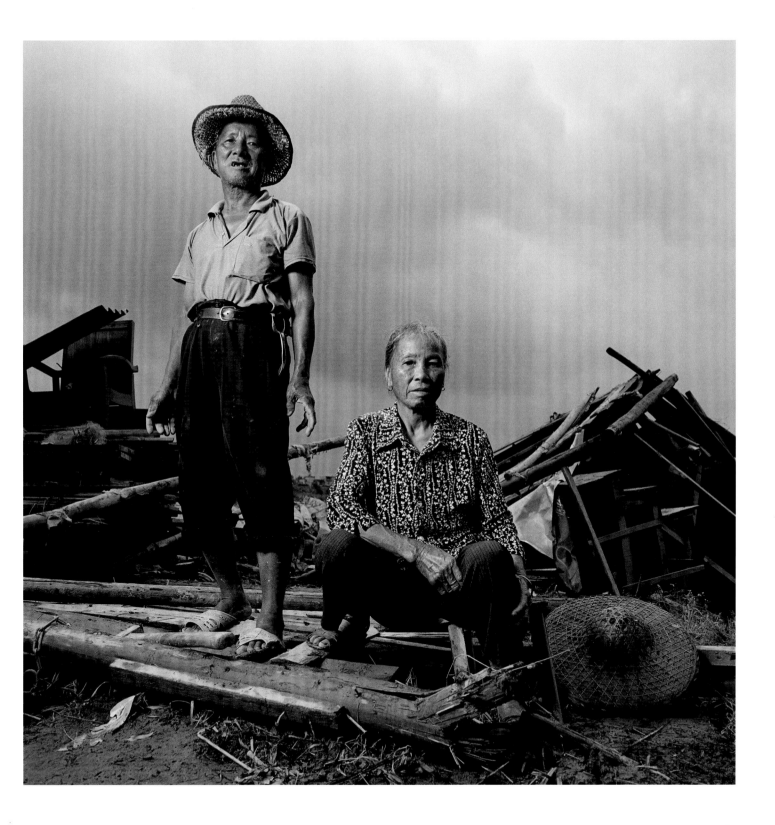

China

Bian Dan (81)
Horse herdsman / Former resort employee
Mengguying, Hebei, China

My family opened a resort here in 1992 and made five hundred
thousand yuan in that first year. But the income started
decreasing soon after, and the resort has now closed. The main
reason is that there is no water in the lake. In the first
couple of years, we had boats and fishing and bridges. But
now, all of this is gone and there are very few tourists.
When I was in my twenties and thirties, there was very good
rainfall that lasted three to five days but now it rarely
rains for more than an hour. This year we have a drought. The
crops are all dead. Ten days ago, we had a dust storm. That
was rare in the past. The sand comes into the house through
the windows or through the door so that even inside you
cannot open your eyes. There is salt and alkali from the
dried up lake bed in the dust. It looks like a white storm.

Anguli Lake is one of the biggest splotches of blue on maps of northern
China, but for most of the past ten years, it has dried to a pale
alkali dust as a result of rising temperatures, prolonged droughts, and
unsustainable irrigation demands.

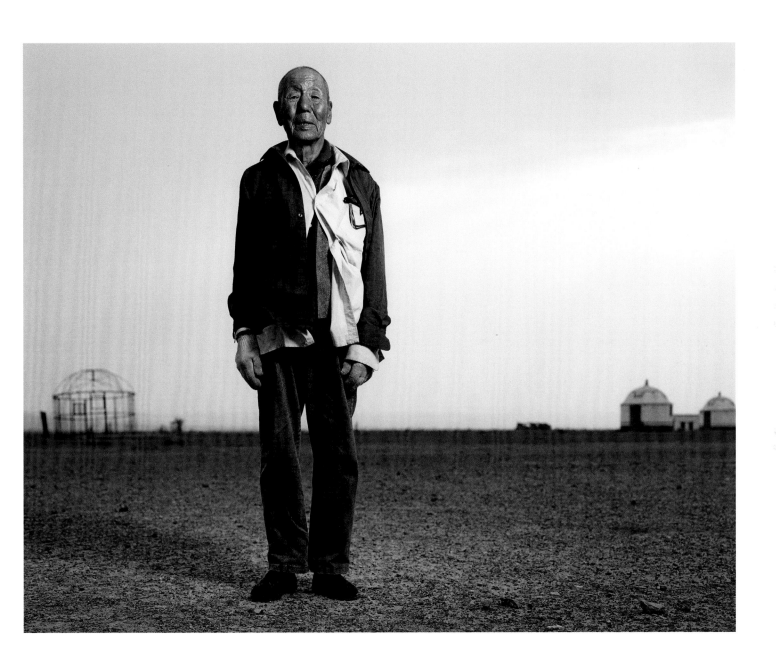

Thailand

Wanee Mainuam (60)
Fisherwoman
Khun Samut, Samutprakarn, Thailand

My income has fallen because the sea is too hot and the temperature is killing the fish. It's like boiling water. This should be the rainy season but it is unusually hot. I feel like fainting when I go out. In the past, there were many kinds of creatures in the sea that we could live on. Now it is harder to survive. The plants in the water are dying and so other creatures have no habitat.

My biggest hope is that we have a barrier that protects us from the waves. I have moved our home eleven times because the waves have destroyed the coastline. The storms keep destroying my home so we have to move. There were no storms before. Only a rainy season. If things go on like this, I think this community will be destroyed. I will have to move away but I do not know where to go because I am illiterate and I do not know how to do anything other than fishing. I don't want to move. I love this place.

The fishing village of Khun Samut is fighting a losing battle against the elements. Fierce heat is killing shellfish farms, while intensifying storms and rising sea levels are compounding the coastal erosion caused by up-river dam construction.

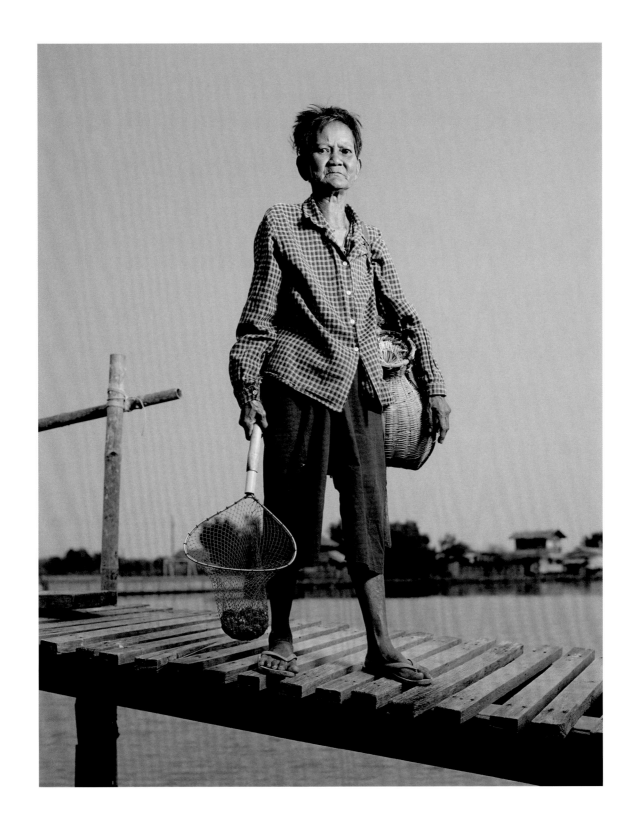

Russia

Avetik Nasarian (50), Ludmila Nasarian (37),
and their daughter, Liana (5)
Bus driver
Yakutsk, Siberia, Russia

We are afraid of living here. The ice underneath our house
is melting. It is like living on a boat. Each year the house
sinks lower and gets flooded so we have to raise the floor
another few centimeters. One day, I will have to crawl through
the door. Our house is damaged by bad drainage because the
road outside is higher than our home, but climate change
affects us a lot. Summers are getting warmer and winters
shorter, so that is why we have more problems than before. If
it gets warmer, we will have more water below our home and
the soil will become less stable. One summer, I think this old
house will collapse.

Yakutsk, which bills itself as the coldest city on earth, is warming
twice as fast as the global average. Scientists are divided on the impact
this is having on the seventy-meter-thick permafrost on which the city
is built. But residents of old wooden buildings on exposed areas of land
in the Sakha Republic (of which Yakutsk is the capital city) witness
structural and flood damage from melting foundations.

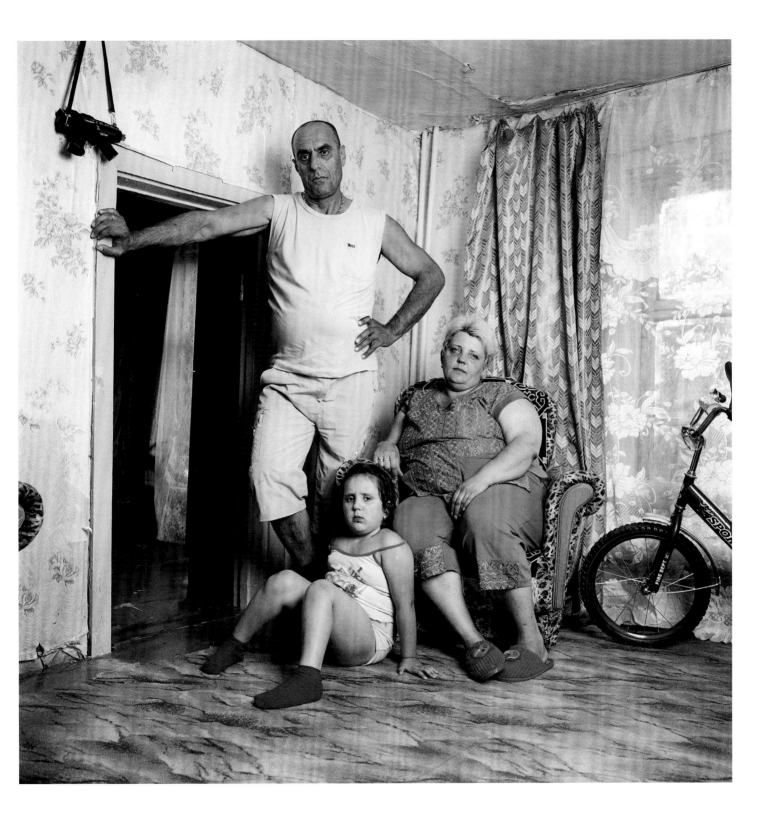

Russia

Koshuneva Luiza Arkadievna (54), in front of her home
partially flooded by meltwater
Siberian pensioner
Namzi village, Sakha Republic, Russia

For the last three years the winters have been warmer so the
permafrost has melted and the lake has expanded so much
that it has reached our home. Now many of our buildings are
submerged. The cowshed, the outside shower, and our under-
ground cool room are all flooded. The weather has changed a
lot. When we were children, the temperature in winter fell
as low as minus sixty-three degrees Celsius, but now it is
much warmer. Other people in the village have similar problems.
My aunt, who is now eighty-six, also has a home threatened by
a lake. Many buildings in her area have been flooded. We
will go to our local administration and ask for a new house
in a higher area.

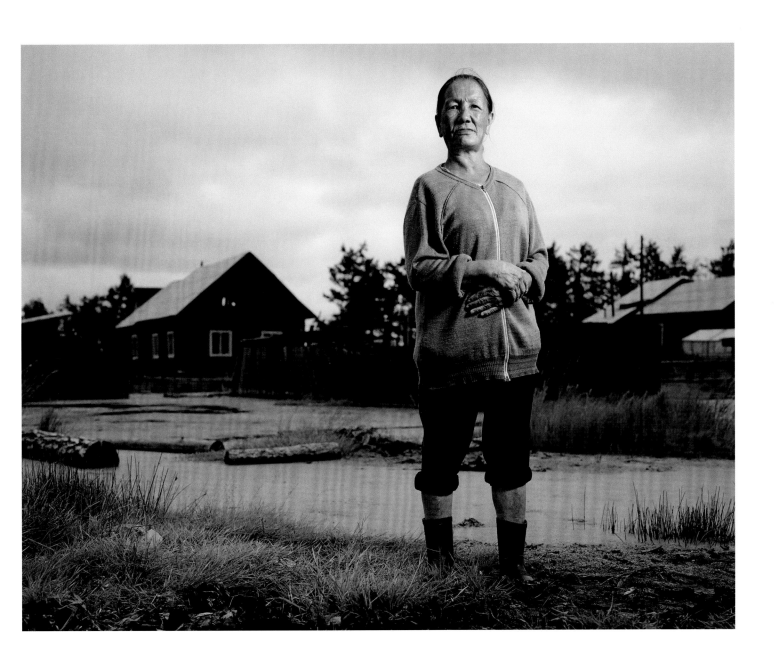

NORTH AMERICA

Canada

Alaska

USA

Canada

Billy (74) and Eileen (52) Jacobson
Inuvialuit / Hunters and trappers
Tuktoyaktuk, Northwest Territories, Canada

The polar ice cap has been there forever, but now it is
breaking up. The snow is melting faster and it is more
dangerous to travel because there are more air holes in the
ice. Over the last five years, we have seen changes in our
camp because the bugs stay longer, birds that we have never
seen before have started showing up, geese are migrating
earlier, and bearded seals come further inland because they
have no ice to sleep on. But the biggest change is the
decline of the caribou. Nobody knows why. Also, their fur
does not get thick as quickly as in the past. Same with the
foxes and martens. So the trapping season is shorter. If it
keeps getting warmer, I don't know what we will do for a
living.

In Canada's Northwest Territories, locals, including indigenous Inuvialuit
hunters, say melting arctic ice is having a noticeable impact on wildlife
and coastal erosion.

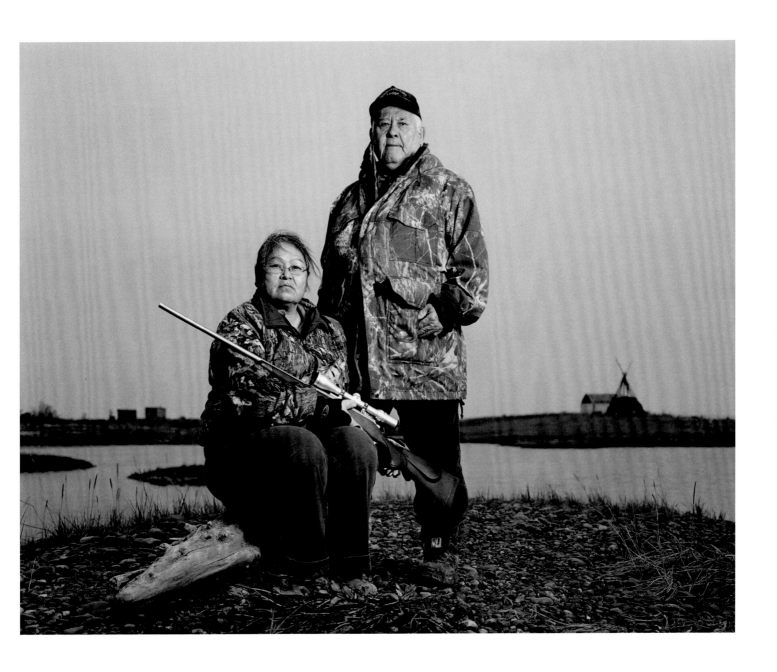

Canada

Sandy Adam (55)
Inuvialuit / Whaler and hunter
Tuktoyaktuk, Northwest Territories, Canada

My house is at risk. I do not know how long it can last
here, perhaps ten years and then it will be gone. You can
see how much the land has eroded. The beach used to be a
thousand feet over there. Underneath us is just permafrost,
and it is all going to melt away. As soon as it gets any
warmer we will sink. My son lives in Calgary now and last
year he came for a visit and he saw a lot of changes and he
said, "Oh my goodness, you guys are going to be swimming
in the water pretty soon." We will move to higher ground at
Reindeer Point, but the land is eroding over there, too.
It is the same all over the place. It's getting warmer. The
snow does not get hard anymore, it is like sugar. When we
were young, we would get excited if we saw an iceberg. But
now more of them come in from the breaking ice.

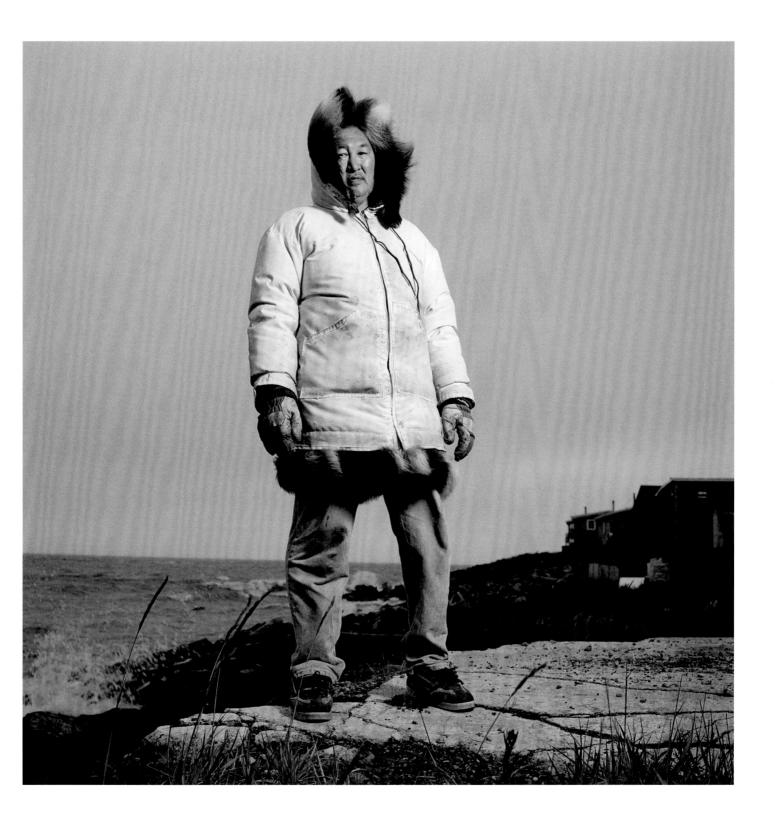

Canada

Roy Friis (64)
Marine consultant / Ice pilot
Tuktoyaktuk, Northwest Territories, Canada

The sea ice is not replenishing itself the way it did thirty-fifty years ago. When I came up here in 1977, the ice pack was fully three meters thick, there was significant ice cover everywhere, and the polar cap did not break up. But twenty years later, the edges of the polar cap broke during the summer. The ice is now less than two meters thick, and the area it covers has been reduced by almost twenty-five percent, so those are big numbers. More old ice has broken away from the polar pack edge and it is drifting down into areas where we did not see it before. This makes my job a little bit more complicated. Old ice is very hard and, unlike new ice, it is a real danger to ships.

I suppose the Northwest Passage will open up but I would like to see that our Canadian coastguards remind the shipping community around the world that it is not just an open sea passage that any ship can go through. It will require special care, temperatures will be freezing still, and a ship should not go through the Northwest Passage unescorted.

The break-up of the Arctic ice cap has affected Canadian ice pilots, hunters, and residents of coastal communities whose homes are threatened by erosion.

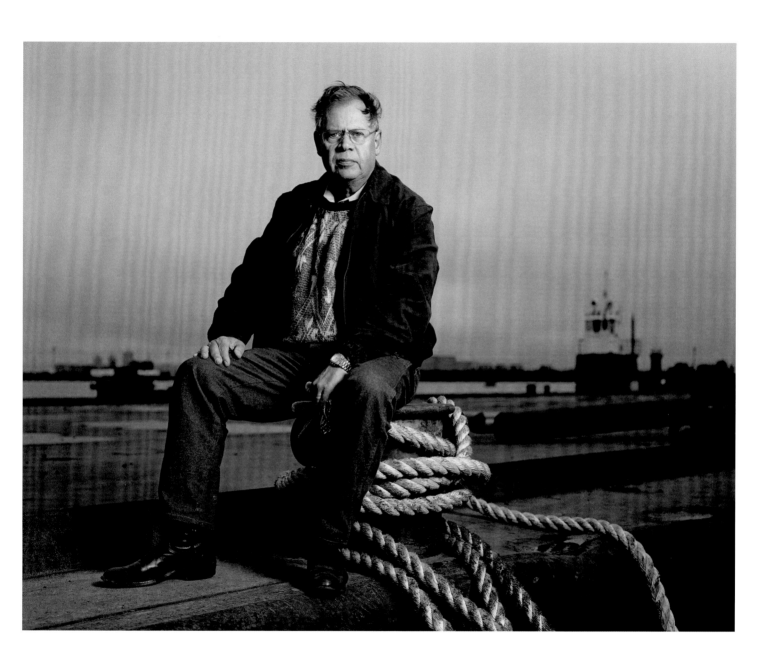

Alaska

Margaret Aliurtuq Nickerson (54)
Yup'ik Eskimo
Newtok, Alaska, United States

I don't want to move, but we are left with no choice. We are
definitely going to lose our land. You can see the permafrost
melting, it goes way deep, and when the land is too much for
it to hold, it collapses. The weather is changing; instead
of getting better it is getting windier and rainier. Our
leaders say it is not happening. How ignorant of them. They
have to come and live here and see how it is. Will they like
it? I do not think so! We used to be an inlet, but now we are
just an island and maybe in less than ten years this will
have been washed away. So, we have been preparing. We have
picked five possible sites. If there is permafrost underneath
we do not want to live there because we might have to move
again. I do not want to move to Anchorage or Bethel. I will
lose my language, my children may lose their language, and,
of course, in bigger cities there is the availability of
drugs and alcohol.

Newtok is a native village in Western Alaska. Within the next few years
the hamlet will be destroyed by erosion that is caused by melting
permaforst and the swelling of Ninglick River. The three hundred twenty
Yup'ik Eskimos living in Newtok will have to relocate soon.

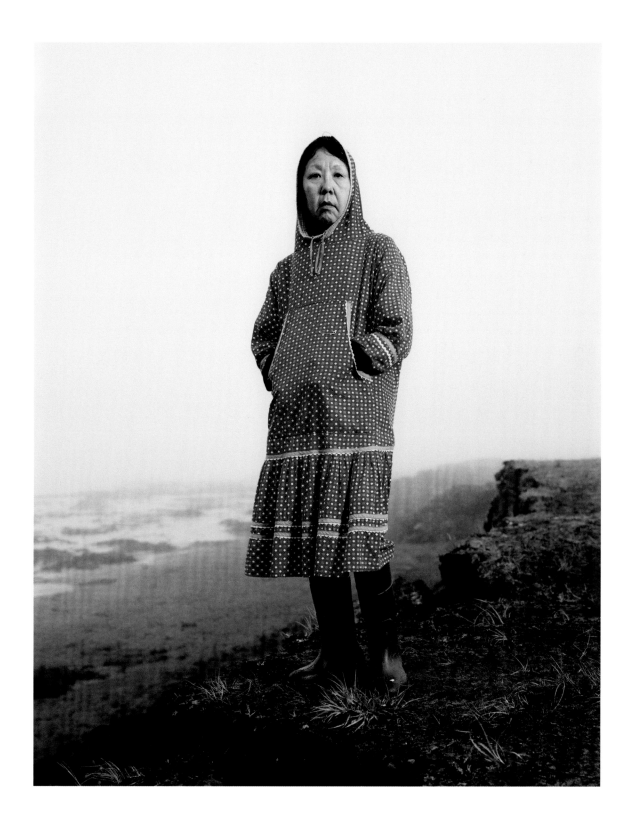

Alaska

George Tom (61)
Yup'ik Eskimo / Hunter
Newtok, Alaska, United States

I had to move out of my old home. The ground got softer and
wetter, and the house started sinking. When I was young it
was okay, but over the last twelve, fifteen years, the
permafrost has been melting. Some people try to level their
houses, but they keep sinking, so they have to do it every
spring or summer.

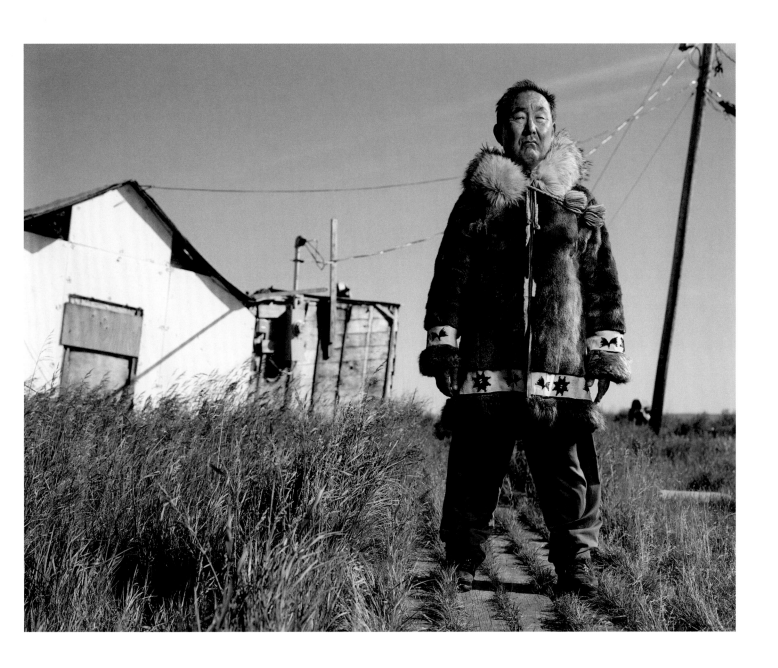

Alaska

Grant Kashatok (46)
Yup'ik Eskimo / School principal
Newtok, Alaska, United States

We have lived here for thousands of years, and this is the
land that we know. But now people talk about relocating us
into cities. What is happening is that the river is exposing
the permafrost under Newtok and eating away underneath so it
just falls into the water. It is happening at a much faster
rate than in years past. Five years ago, there was a pile
driver right on the water's edge and then it fell in and now
it is four hundred feet away from the shore.

When we were younger, our houses were covered by snow and we
could only see the chimneys and we would slide down the roof
tops, but we do not see that anymore. The winters are too
warm. I do not think it is possible to relocate us. We would
be out of our environment. If we move, we will not be Yup'ik.
It literally translates to being a "real person." If we
leave here we are no longer real.

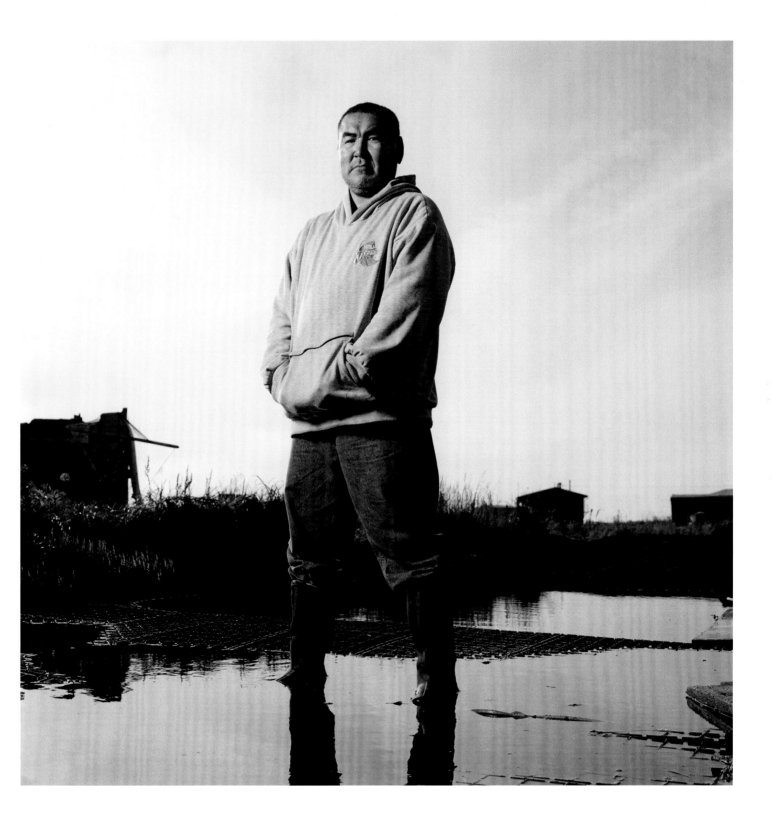

USA

Scott Sutton (44)
Superintendent of the Wild Horse Golf Course
Las Vegas, Nevada, United States

The golf courses in Las Vegas are going to dry up. No water means no grass. That means no golf courses, I mean, that's unfortunately the bottom line. When I was a kid, the lake was full so you could water what you wanted. In the sixties, my dad actually put in Dichondra, which is a water-loving plant. Now, nobody would do that. The lake has dropped dramatically over the last twenty years, as the population of the valley has exploded. I think it's a combination of less snow on the west side of the Rocky Mountains, less water flowing into the lake, and more people pumping water out of the lake.

The government has changed the laws. Golf courses are not allowed as much grass. There is also a rebate program to take out grass. The Wild Horse Golf Course is reducing its water usage by pulling unnecessary sod out and replacing it with desert adapted plants. There is no choice. I think it's either that or, as humans, we just consume everything until there is—nothing left.

The climate in the American Southwest has become drier, mainly caused by the diminished snow pack in the western Rocky Mountains. Las Vegas is one of the most affected cities. Great efforts are being made to conserve water, which is becoming more expensive. The Southern Nevada Water Authority pays golf courses one dollar per square foot to remove turf grass.

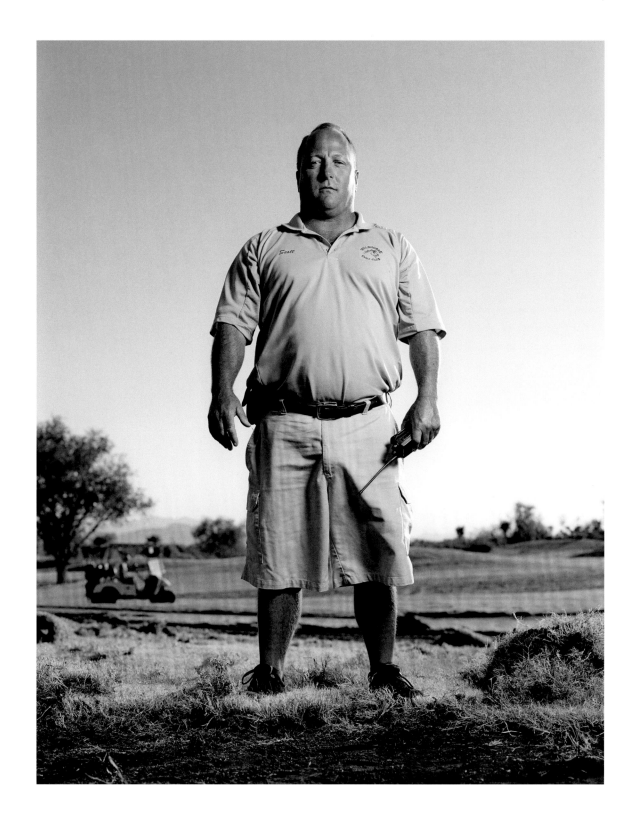

USA

John Glance (55), standing on land right behind his house,
which was burned by the "Station Fire" in September 2009
Musician
Acton, California, United States

The fire took out some fences. It took out some poles, some
irrigation. It jumped over the barns, lit the pastures
alight on both sides, and came round one side of the pastures.
We were lucky we survived. The winds blew in our favor at
the last second. The cause hasn't been determined. There are
fires in California pretty much every year. It's inevitable,
but not usually at this time. It seems that the seasons are
changing, you know, summer stays longer, comes later. Same
with the winter—seems to come later and stays longer. We are
definitely in a drought, that's for sure. I can't imagine
there isn't something happening; it seems that things are
getting slightly warmer; it seems that the seasons have
changed and there seems to be scientific evidence to back it
up. The number of us and what we are doing with our cars—I
mean, check out an L.A. freeway on any Monday morning—there
is no earthly way that it's not having repercussions, and
this is happening all over the United States, and presumably
all over the world.

In the last twenty to thirty years the frequency and intensity of
forest fires in California has increased. A main reason for this is a
warmer climate. The Station Fire that burned for weeks in the San
Gabriel Mountains, east of Los Angeles, in the summer of 2009 scorched
336,000 acres of land and destroyed hundreds of structures.

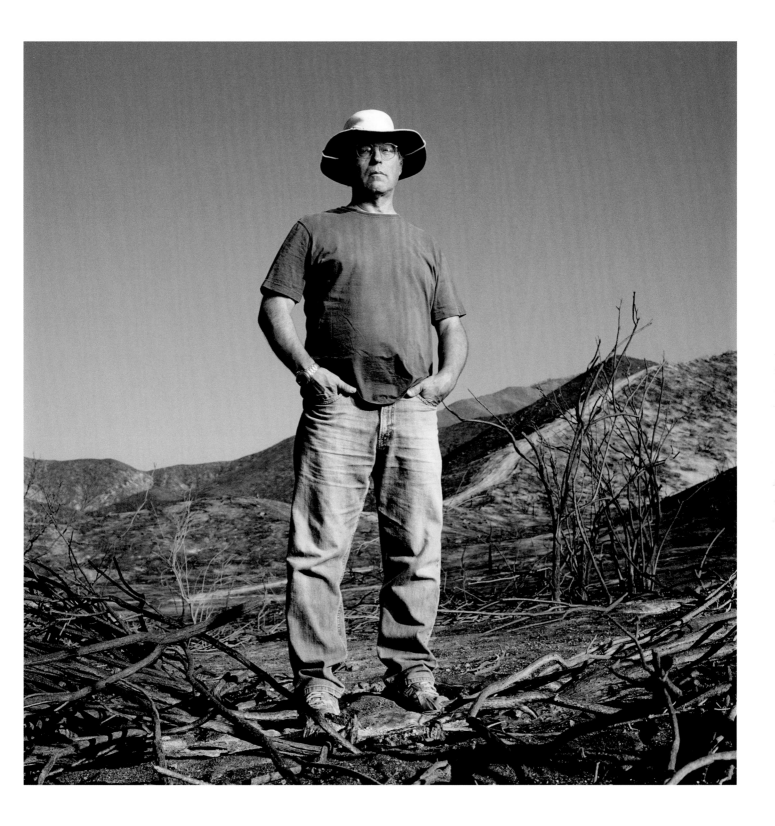

USA

Chris Brower (43)
Organic produce vendor
Silverthorne, Colorado, United States

We had a couple of years of really bad droughts, and the
beetles just took over and decimated the place. From the mid-
to early nineties, you could see them spreading, every year
getting a little bit closer. Now, our area is surrounded by
brown, mostly brown, and it used to be mostly green. When
the trees are healthy and it is wet, they can produce enough
sap and zap the bugs right out, and now they are not able to
do that. The bugs do not die out in winter because it is not
getting cold. I read in the paper that one hundred percent
of the large pine forests will be dead in Colorado in the
next five years. It is really kind of sad. It feels like the
end of a time period for this place, and I talk a lot about
this with my wife. It does not feel as vibrant, as alive as
before.

Pine beetle infestations are a growing problem in Colorado. Swathes of
forest are being destroyed because winters are no longer cold enough to
kill off insects, and the trees' defense systems have been weakened by
drought.

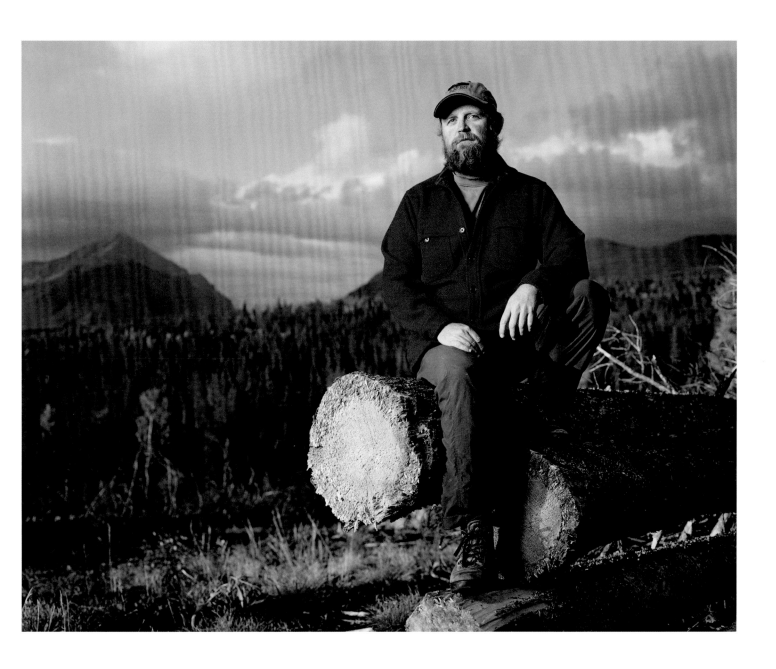

USA

Christie Powell (66), standing in the remains of her house
Wildfire victim
Santa Barbara, California, United States

The morning after the fire, everything I owned was suddenly
gone. My kids took me in, so I had a bedroom. It is really
nice to be with the grandchildren; but I woke up in the
middle of the night in a way that I had never done before
and I cried. There have been three fires in one year in this
part of the world. That's unheard of. We have less rainfall
than we consider normal. It seems hotter to me. These hills
used to have touches of green and now they're brown. I guess
what happened is that when the brush gets to a certain degree
of dryness it can almost ignite by itself, so the least
little thing will set it off. It is radical climate change.
I think that we have to find some way to live with our chins
up and face what's really coming down.

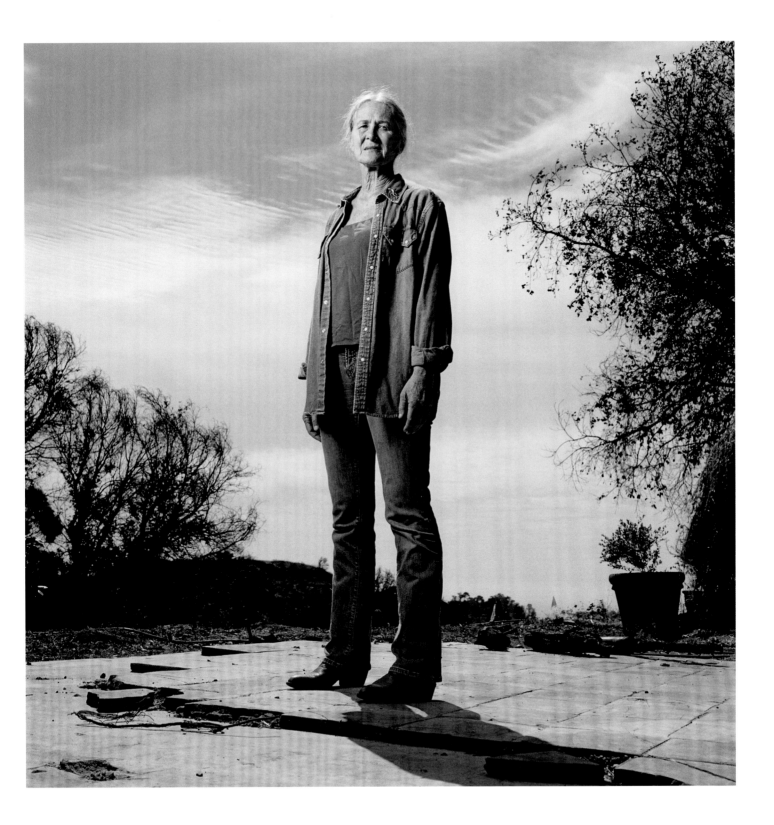

SOUTH AMERICA
CARIBBEAN

Peru

Cuba

Peru

Juliana Pacco Pacco (44)
Lama herdswoman
Paru Paru, Peru

When I was a child, these mountains were very beautiful, but
this is changing. They are very ugly now. This is surely due
to the change of climate. The weather is very bad. It rains
and snows at unexpected times. There used to be many pastures,
but in recent years everything is changing and becoming very
difficult. The animals don't have much fodder to eat and are
more prone to illness, so the herds have decreased, and
the animals are not as fat as before. If production is low,
our children will be hungry, so perhaps there will be more
migration. The children may look for work elsewhere.

In the Peruvian Andes, temperatures are rising, precipitation patterns are
changing, and some of the world's highest ice fields, including that on
Mount Ausangate, are melting. The potato crop is so plagued by heat-
related diseases that locals have shifted cultivation to higher, cooler
ground. But they have reached a limit: above the farm fields now is only
rock.

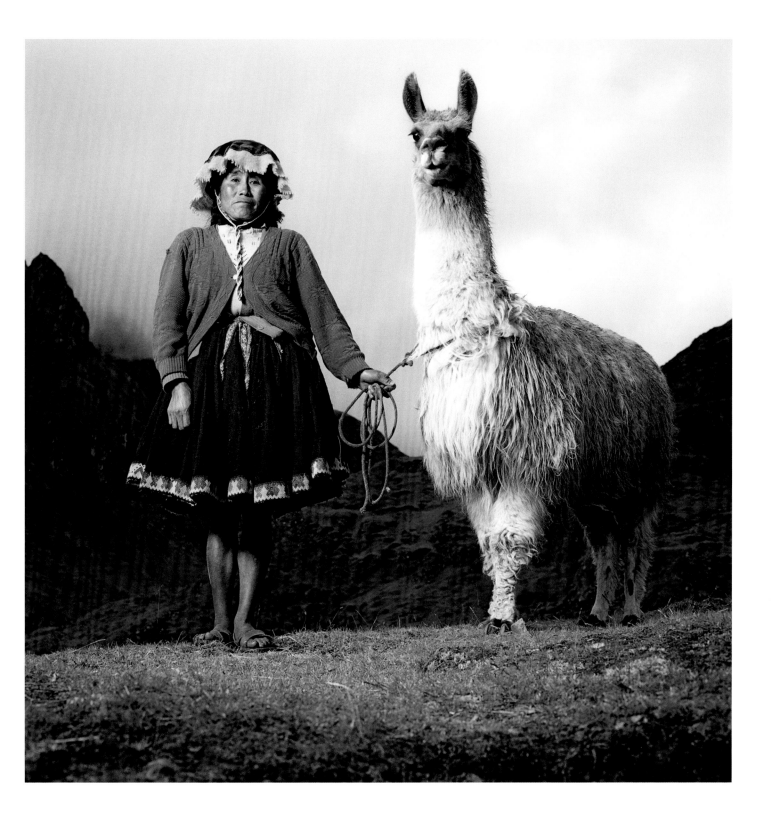

Peru

Mariano Gonzalo Condori (48)
Farmer
Pucarumi, Peru

We are losing our glaciers. They are turning into water, and
we have fewer snowfalls. If this continues, surely the water
will run out and then how are people going to live? This
will surely bring a famine, animals will die, and there will
not be much agriculture. Potatoes use to grow only at an
altitude of 3,200 meters, but now we can cultivate them at
4,200 meters. Perhaps even higher later. When I was young,
the soil was very fertile, but now it has become poor. When
it used to snow, everything was very white, and Ausangate
(Peru's second highest mountain) looked beautiful. Now the
snowfalls are disappearing and it has become ugly. Scientists
tell us there will only be water for twenty-five years. We
do not know what to do. We are very concerned.

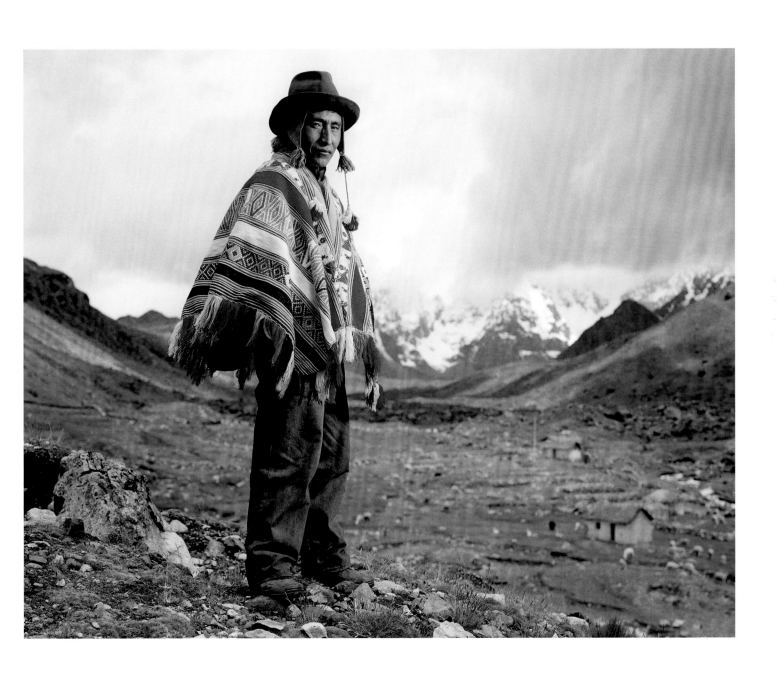

Peru

Gomercinda Sutta Illa (54) and her grandson,
Richar Guerra Sutta (10)
Farmers
Chahuaytire, Peru

We are worried that we may not have enough food. The snow came
at the wrong time of year and ruined our potato crop. Beans
and oats were also damaged, but potatoes were affected the
worst. Those that survived the snow are flowering at the
wrong time. They are diseased. The harvest won't be good. The
weather is unpredictable. The last few years have been too
hot, which affects the land, and the rain falls during the
wrong seasons. I am worried for my children. They will face
many problems when they grow up.

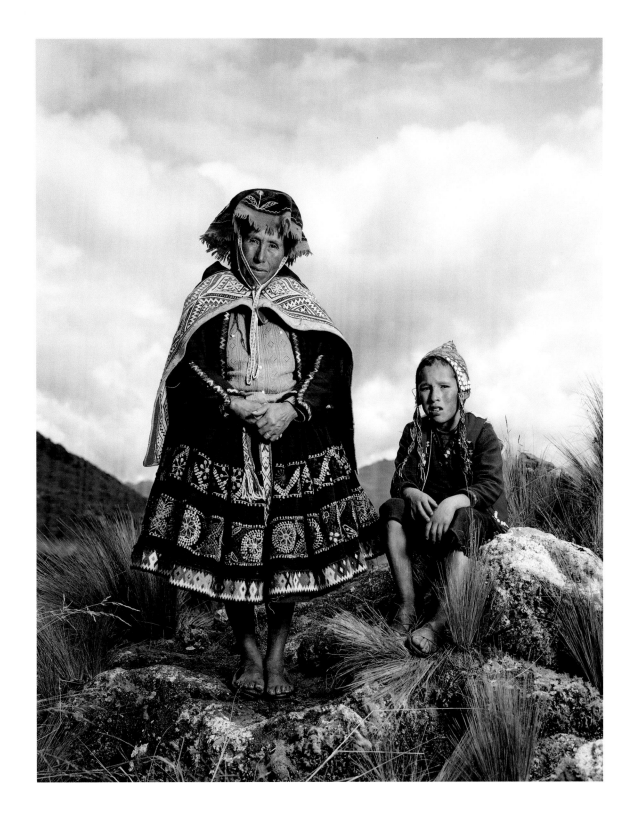

Cuba

Yusnovil Sosa Martínez (33) with his wife,
Antonia González Contino (41), and her son, Yosdany Miranda
González (10)
Public health worker
Sanguily, Pinar del Río, Cuba

We had just started repairing the damage from one hurricane
(Gustav) when the second one (Ike) hit. We didn't have time
to do anything. The first cyclone was incredible. It was
bigger than we expected. In this municipality, we had only
experienced small hurricanes before. Now they come more
frequently. Before we had one hurricane a year, now there
are two or three. You have to live through one to know what
it feels like; it is a total disaster. You go out and see
one thing and then, when you go out again, you do not see
that anymore, it's all gone. The hurricanes are stronger
now because the atmosphere is more charged. We have all
contributed to global warming and we must try to do
something about it or there will be more disasters. It might
not be us who suffer, but if measures are not taken, then
perhaps our children will have problems with the warming of
the atmosphere.

Cuba's province of Pinar del Río was battered by two powerful hurricanes
within eight days in 2008. Gustav destroyed thousands of houses. Ike
followed with a deluge. While individual events cannot be directly ascribed
to climate change, they are consistent with meteorologists' predictions
of increasingly fierce and frequent "extreme weather events" as atmo-
spheric temperatures rise.

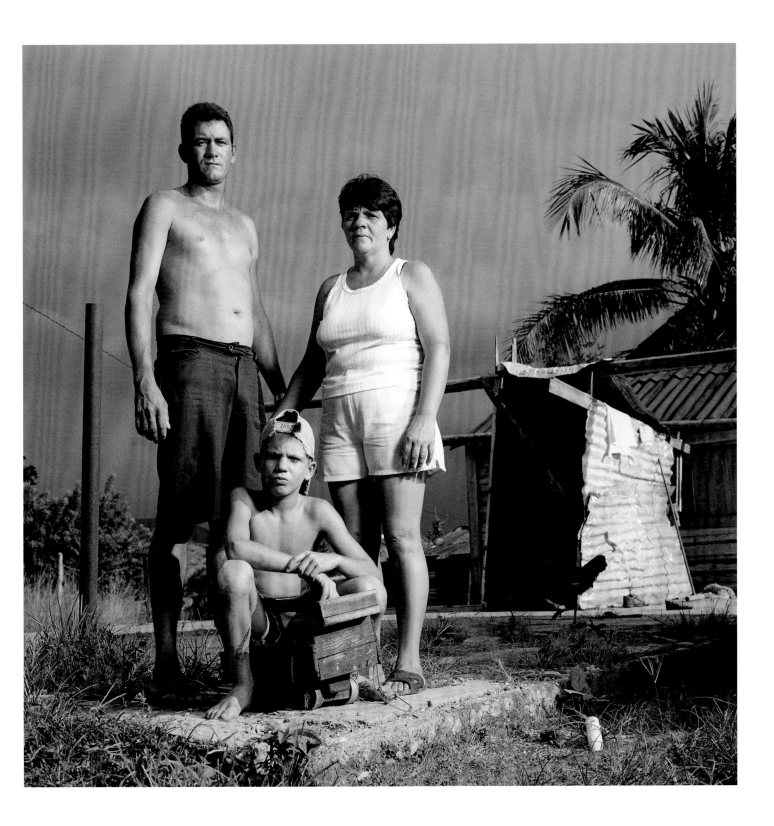

Cuba

Estrella Sosa Osorio (40)
Fisherwoman
Playa del Cajío, Havana, Cuba

When the hurricane came we moved to a shelter, and when we came back the water was at waist height and there was nothing left inside our house. Now the streets have been cleaned and it all looks better. We have gone through the toughest time. At the moment, we do not have anything to drink because the water tanker has not arrived yet. The old one was broken by the hurricane. Even if we pray to God, I do not think the hurricanes are going to stop. It is not normal to have one after another. But this is happening more than before and they are coming with more intensity.

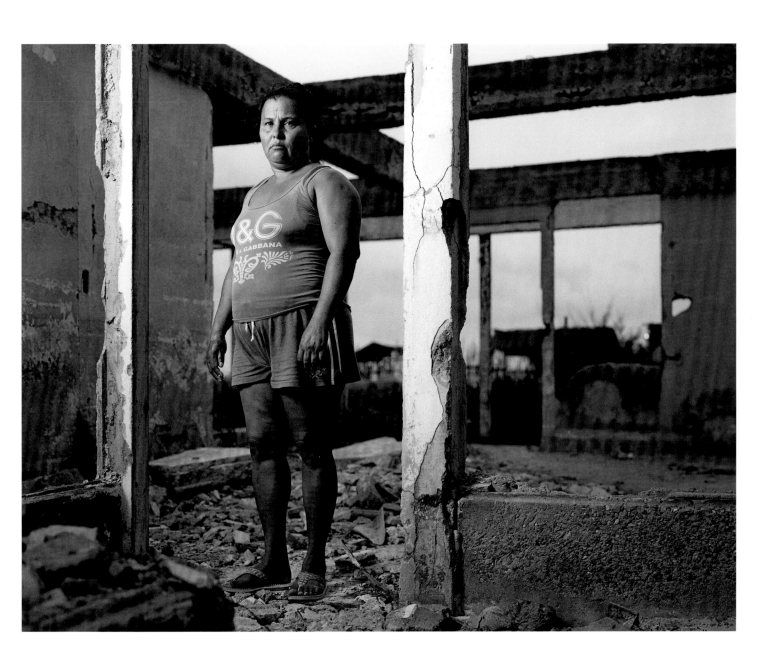

Cuba

Bárbaro Rodríguez Maura (45), his wife, Yusimi González
Contino (33), and her daughter,
Yusimari Miranda González (15)
Driver, teacher, and student
Sanguily, Pinar del Río, Cuba

We had never seen such a hurricane here before. The first
one brought a lot of wind and destroyed houses. The second
brought a lot of water. We stayed at my sister's home, which
was safe. We looked through the window. To me, it seemed
to last a year. The first pulled up trees, bushes, and
floorboards. After a while there was a moment of calm that
made you think it is over but then there were more whirls.
After the hurricane passed, and we heard the all clear on
the radio, we came out and saw the disaster. Many houses had
collapsed. There was debris everywhere. There was only the
back part of our house remaining. The roof had gone. It was
probably in the middle of the vegetation.

We had storms here before but never anything like these
hurricanes. When I was a child, I do not remember so many
strong rains. The thunder and lightning are fiercer. If the
atmosphere keeps changing and it keeps on raining more, with
lightning that strikes near us, I do not know what is going
to happen.

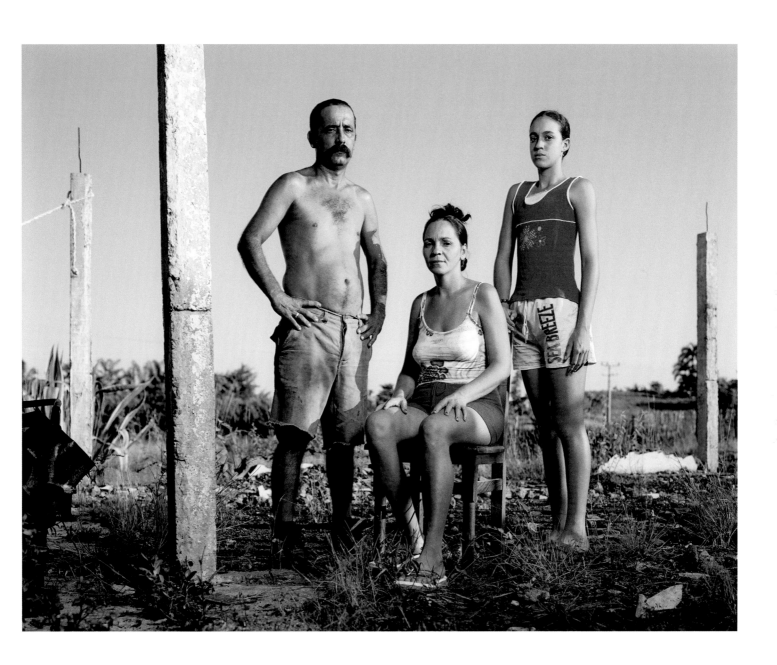

AUSTRALIA / OCEANIA

Australia

Kiribati

Australia

Michael Fischer (60)
Dairy farmer
Meningie West, South Australia, Australia

I've built this place up over thirty-eight years. We were
very successful with a six hundred cow dairy. But fourteen
months ago, we had to dispense with the dairy because
there was just no water. We are seeing extreme heat. I was
convinced that the rains will come and we'll be back in
business again. But the next year we had restrictions again,
and the water was getting very saline. We had a lovely
little golf club. That's gonna go. They've got to buy the
water back, but they won't step in the market and buy big.
It's political and it shouldn't be. The Murray-Darling basin
is the fruit bowl of Australia. But there's not gonna be
very much of it shortly because the water is running very
low.

Large areas of Australia have endured an unusually severe drought for more
than a decade, resulting in the devastating Victoria bushfire in 2009
and severe agricultural losses in the Murray Basin.

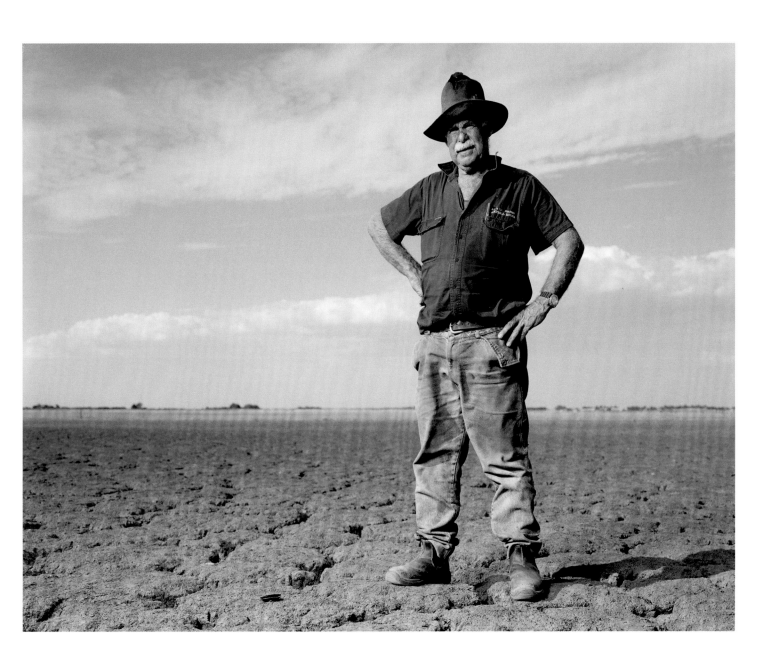

Australia

Greg Liney (60)
Viticulturist / Victim of the 2009 Victoria bushfire
Healesville, Victoria, Australia

I've had a cry. There's no doubt about that. Once I came
into the vineyard and saw what had happened, I found it a
little difficult to get out of bed in the morning. The
aftermath of the fire has been quite devastating. The fruit
burned from the bottom. You can see how hot it was. The
leaves withered and died. My income has been devastated. The
things I planned for in the past may not come to pass.

On the day of the fires, it wasn't one or two degrees warmer
than our last warmest day, it was five or six degrees
warmer. Those sorts of peaks don't normally occur. There's
something else going on with the weather patterns. They're
changing. We have had droughts before, but I think there are
other elements that are starting to emerge now. What I've
seen here is a definite trend to warmer and drier weather. I
can't see how we can look back on the last two hundred fifty
years and say we're not mucking things up. People need to
make decisions and start acting. My generation is largely
responsible for a lot of the recent damage that's going on
around the planet. And I think it's my children that are
going to have to suffer the consequences and their children
as well.

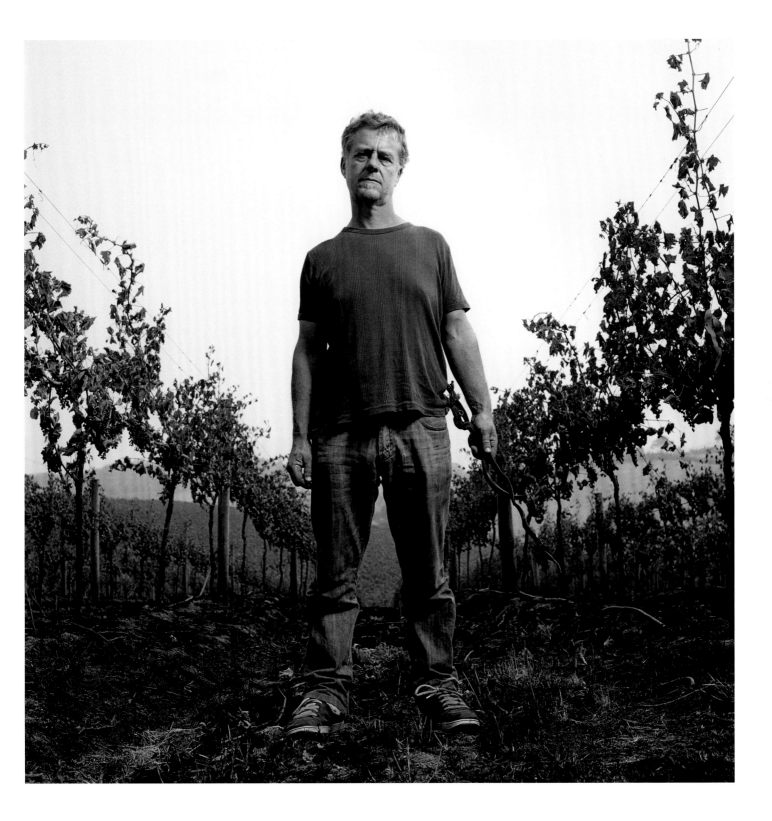

Australia

Ken Butcher (57)
Sheep farmer
Booroorban, New South Wales, Australia

We're in a situation now where I have virtually no feed. We are virtually out of water as well, so I have to reduce stock. There is no choice. We have just about exhausted most of our excess, which means going into debt. If it stays dry, there is no way of paying it back. There comes a time when you have to walk away.

We seem to be running through longer periods of drier-than-normal conditions. I've got to look at photographs to remind myself of what a normal year can be like. It is depressing to see everything so dry and to see trees that you planted die. Some of my neighbors take the worst option out and commit suicide to get away. I try to maintain a positive outlook that hopefully things will get better.

After a severe, thirteen-year drought in southeast Australia, farmers are struggling to make ends meet. Ken Butcher has tried to adapt by switching from Merino to Dorper sheep, which are well adapted to a desert climate. But he has still been forced to reduced his stock from two thousand to six hundred sheep. On the day this portrait was taken, he had just put an ad in the local newspaper to sell another four hundred.

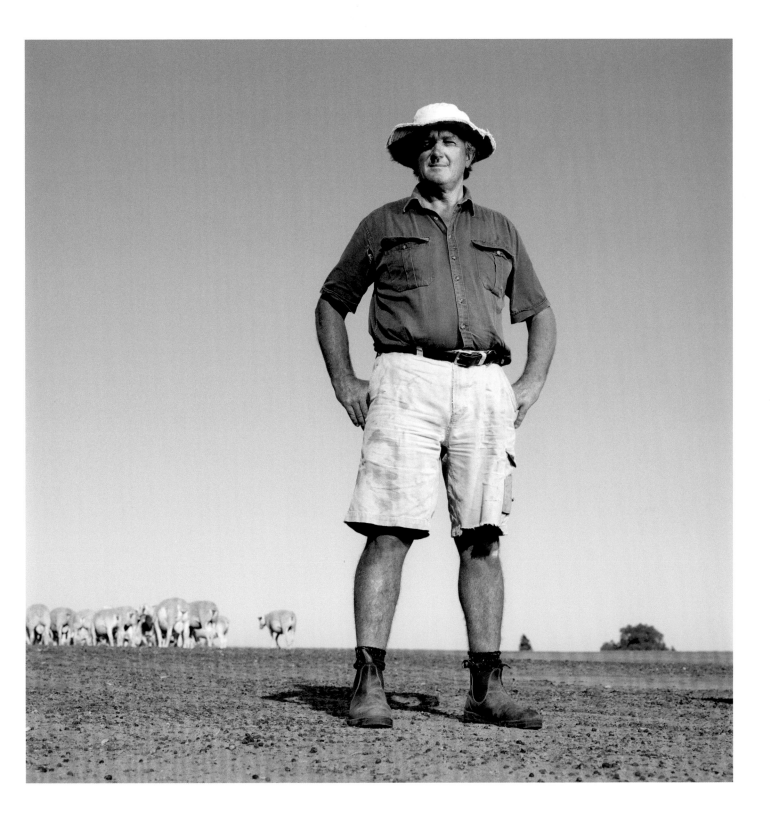

Australia

Patrick Wolfe (60)
Historian
Healesville, Victoria, Australia

I lost my home in the 2009 Victorian bushfire. On the day, the temperature was 47.6 degrees Celsius in Melbourne city, which is the highest recorded for any Australian city since they started doing measurements in the early nineteenth century. No doubt, lightning is also to blame, but this would not have happened in ordinary weather. There is no question these fires would not have developed as rapidly, and as intensely, and across such a wide front as they did had the conditions not been made so bizarrely dry by the unprecedented hot weather that's been going on for an unprecedentedly long time.

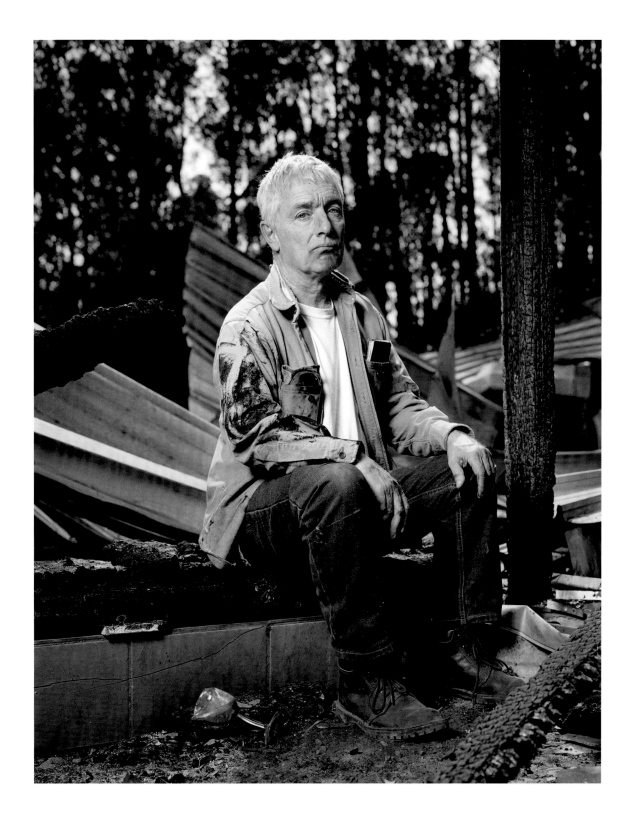

Kiribati

Taibo Tabokai (15)
Teenager
Tebunginako, Abaiang Atoll, Kiribati

We have been told that the land where we are now sitting
will disappear. Our church will go, too. That worries me more
than anything. I don't want to lose what was made in the
past, what our parents built. When we had a storm, it
destroyed the causeway and the seawater went into the ponds.
I would like our government to help us protect the village.
Perhaps foreigners can stop this land from disappearing. But
we've had people come here and explain that there is no hope
for us because we will eventually lose everything.

As on many small island states, the people of Kiribati in the South
Pacific view rising ocean levels and intensified storm activity as
existential threats. They are already losing land to erosion and crops
due to increasing salinity levels.

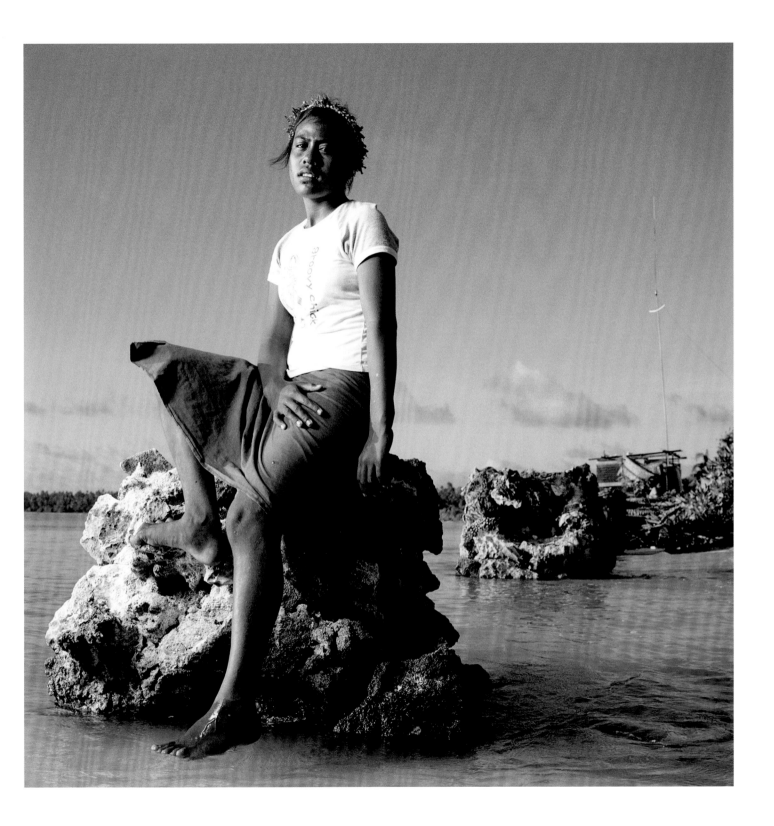

Kiribati

Karotu Tekita (54) with granddaughter Akatitia (1),
his daughter Retio Tataua (34) with son Tioti (11 months),
and his wife, Tokanikai Karolu (52), with granddaughter
Bwetaa (6)
Family living in a sinking village
Tobikeinano, South Tarawa, Kiribati

The sea is coming closer year by year and the coastline is
being eroded. My land is now ten meters out to sea. That is
where I built my home. When we started out here in the
1980s, there were a lot of coconut trees. It was a comfortable,
peaceful place. But now the fruit trees have all died and
our land is just a narrow strip. We live on the edge. If
it goes on like this, we may have to flee. I believe this is
caused by our brothers and sisters out there in the world,
who are really doing a lot of burning and industrial activity
that is damaging the environment and changing the climate.

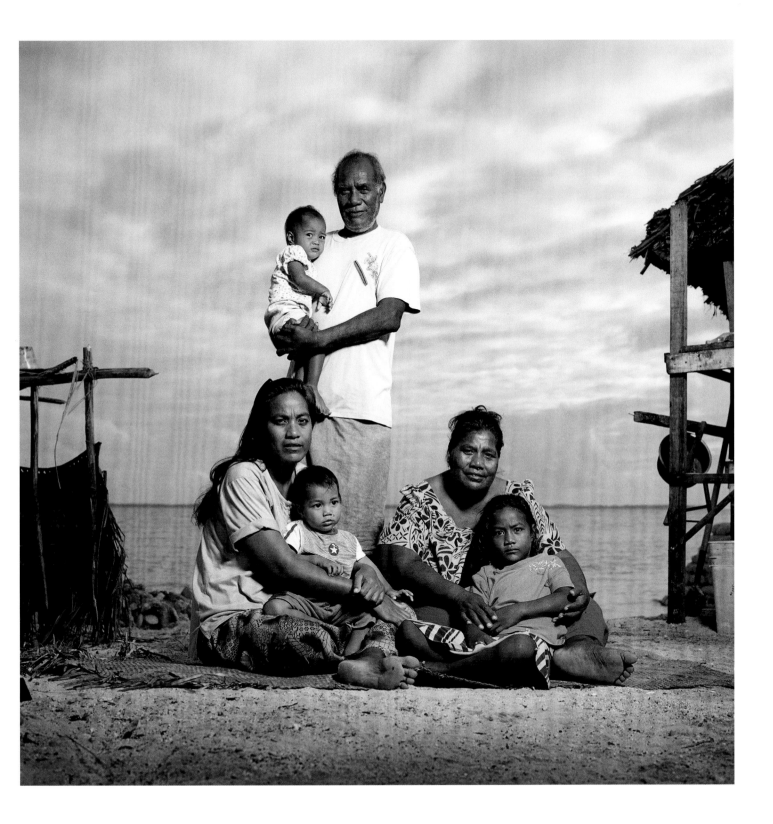

Kiribati

We live in constant fear that one of these days there will be
no more islands left in Kiribati. We have never encountered
problems like those we face today. We've been told to demolish
buildings that we have spent a lot of money on and move them
elsewhere. We have already lost our fish ponds and banana
trees. Erosion has taken the sand where we used to dig for
seashells. It has made life harder for us. At the moment, I
don't have much hope for the future, unless something gets
done. Perhaps we can get assistance from somewhere to protect
our environment or maybe something else will be done to stop
what's been happening over recent years. We don't think this
is a natural problem. It's caused by other people.

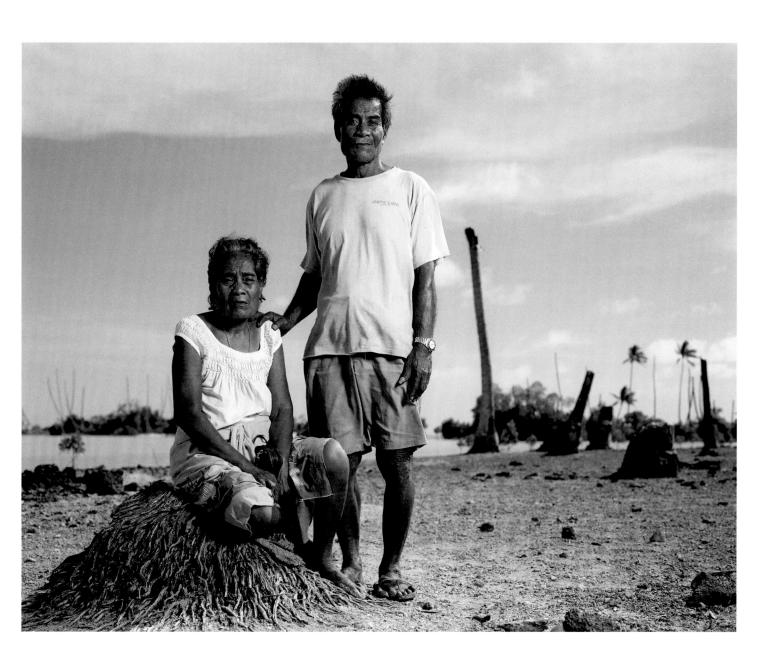

Kiribati

Tutaake Arawatou (59)
Fisherman
Tabontebike, Abaiang Atoll, Kiribati

No islands have been lost before. Now even in Abaiang, there are two or three islands that have actually disappeared. I don't think these changes are natural because we've never heard of anything like this in the stories handed down by our forefathers. I think this is caused by other people, probably by more developed countries.

The sea level has increased since I was nine or ten years old. Nowadays, if there is a high tide, it will wash over the shores and into the taro pits. That didn't happen in the past. Back in 1995 or 1996, we had some huge tides and strong winds that broke the seawall. Seawater spread through the swamp and destroyed all the taro plants that were growing there. That was our main, staple fruit. This has dramatically changed our way of living. Before everything was community based. Everyone had a portion of land, where they could grow taro. Now, people fend for themselves. We have to go and catch fish and earn money individually to buy rice because there's no more taro to go back to. To me, climate change is a scary concept. I firmly believe that our islands will be destroyed if what's happening now isn't stopped.

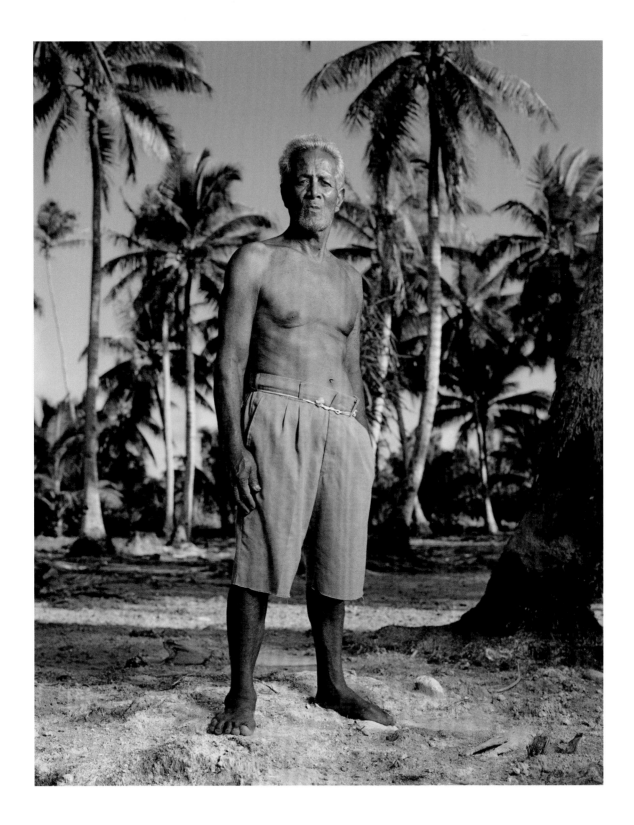

EUROPE

Italy

Spain

Switzerland

Italy

Antonio Esposito (55), in a watermelon field that was
destroyed by a hail storm
Farmer
Bernalda, Basilicata, Italy

I have just lost my entire watermelon harvest to a hailstorm.
We have had three or four this year. They are more frequent
than in the past. One minute it will be raining and the
next thing you know it is hailing, and no ordinary hail. The
ice is deformed. It comes down in rough edged stones. I'm
not a scientist, just a farmer, but we are sensitive to the
weather. The climate started changing about ten years ago.
The seasons are mixed up. The summer was over very quickly
this year. We had ten days of extreme heat, of around forty,
forty-five degrees Celcius and then the temperature dropped
suddenly by around ten degrees. This damages our vines,
peaches, apricots, and other precious crops.

Europe is experiencing extreme weather events, including unusually hot
summers in Spain and frequent hailstorms in Italy. Glaciers in the Alps
are no less vulnerable to the heat than those in the Himalayas and Andes.

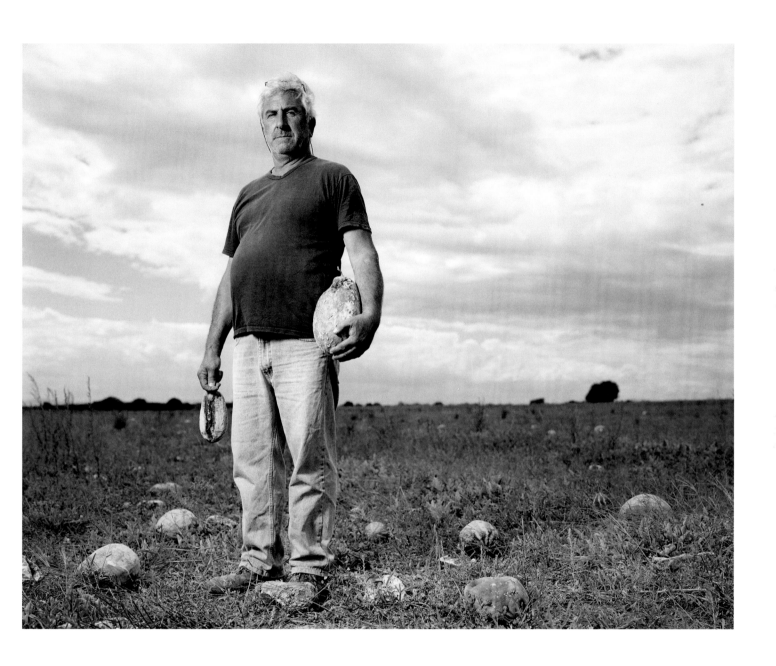

Italy

Marcello Plati (33)
Beach lifeguard
Metaponto, Basilicata, Italy

Over the past three years the change in summer temperatures
has been dramatic. It has gone from thirty-eight degrees
Celcius to forty-six degrees. Some people remain at home
because they are scared of getting sunburned and having sun
spots, like mine. Even for me, it is difficult to work in
these temperatures. I have noticed over the past ten years that
temperatures increase and decrease a lot faster than before.
This means the summer comes without a spring. The other
thing that has changed is the coastline. A storm in December
2008 moved most of the sand that made up the Metaponto beach
twenty, thirty meters out to sea. Given that I live here all
year round, I am able to carefully observe the erosion of the
coastline and have concluded that we lose between one and a
half to two and a half meters of beach each year.

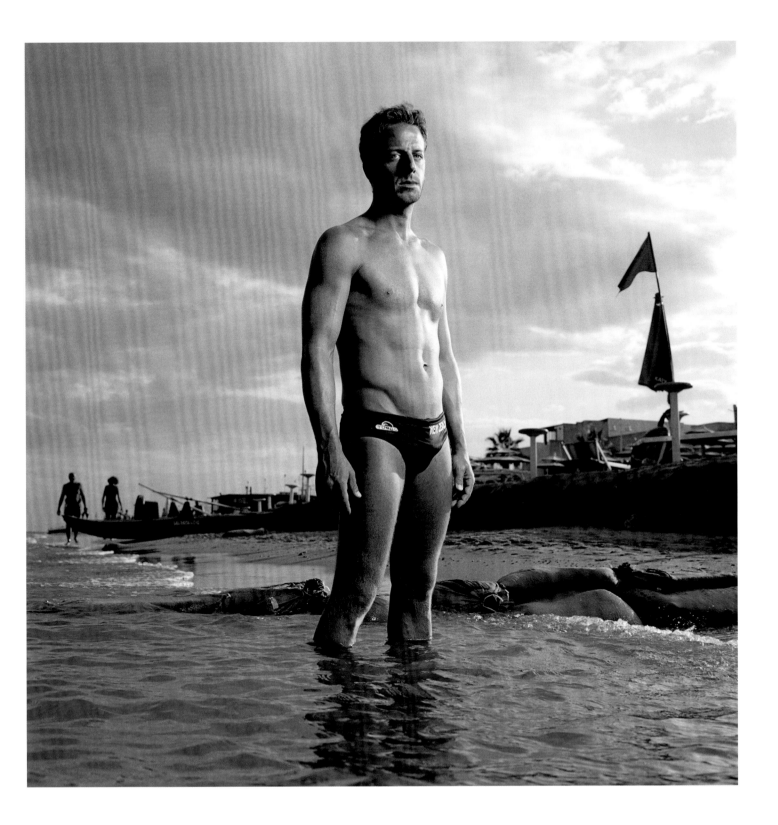

Spain

Miguel Angel Casares Camps (46) and Miguel Casares
Cortina (76)
Farmers
Moncofar, Valencia, Spain

For us, climate change is a stress on our plants, which
cannot adapt to extreme changes in temperature especially in
the summer. These extreme temperatures started ten to fifteen
years ago. In the past, there was a gradual change from one
season to the next. But now it is extremely hot and then
suddenly extremely cold. The plants struggle to acclimatize.
Recently, we lost around ninety-five percent of our pepper
production due to forty-five-degree Celsius heat. Artichokes
are badly affected. Rainfalls are also completely unbalanced.
Before, it could rain three or four days nonstop. Now you get
the same amount in forty-five minutes, which causes erosion.
It has become difficult to cover expenses. If things stay
like this, we will have to change our lifestyle completely.

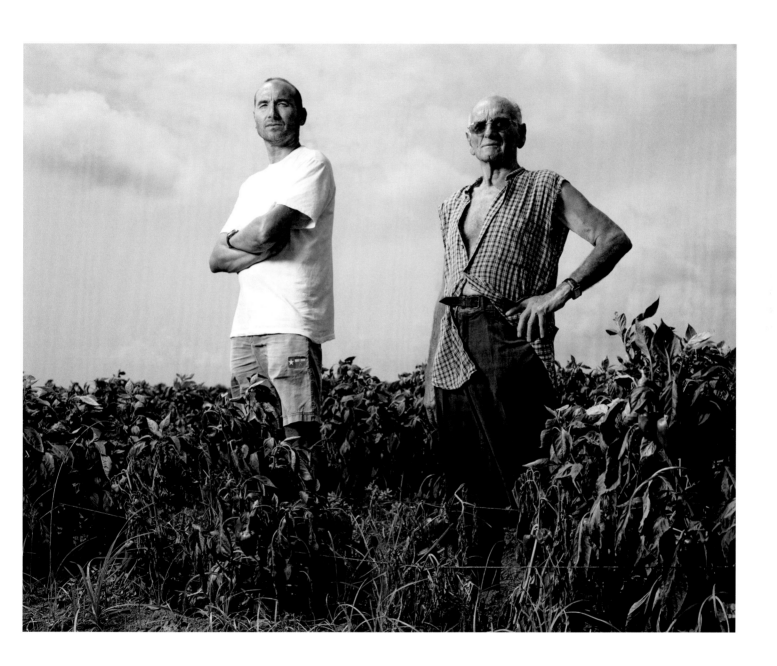

Spain

Angel Oliveros Zafra (49)
Farmer
Villanueva de Alcarrete, Mancha, Spain

I see climate change in the lack of rainfall and the late frosts, which are hurting production and profits. This year, I have lost around eighty to ninety percent of the cereal harvest. Now only the grapes remain, and we may lose forty percent of them.

The rain cycles are not as they used to be. In the past, winter would come to an end around February. April brought some rains and then, springtime started and it also rained. Roughly, it used to rain every fifteen days or so. And now, it may not rain for three, four, five, or six months in a row. We did not have frosts in April like we do now. Just as the buds start to appear, the temperature falls at night, all the sprouts freeze, and the harvest gets lost. In the past, you could harvest three thousand kilograms of barley from one hectare without fertilizing. All you needed was the rains and doing the right work. But for the last ten years, we have not reached one thousand five hundred kilograms per hectare even with machinery, fertilizers, herbicides, and insecticides. What is to blame? The climate. If this continues, more wells will dry up and water will become scarcer. Little by little it is going to become a desert, and due to climate change, not a single plant will be able to grow. Hopefully, many years will pass before this happens, but the pace at the moment is uncontrolled and unpredictable.

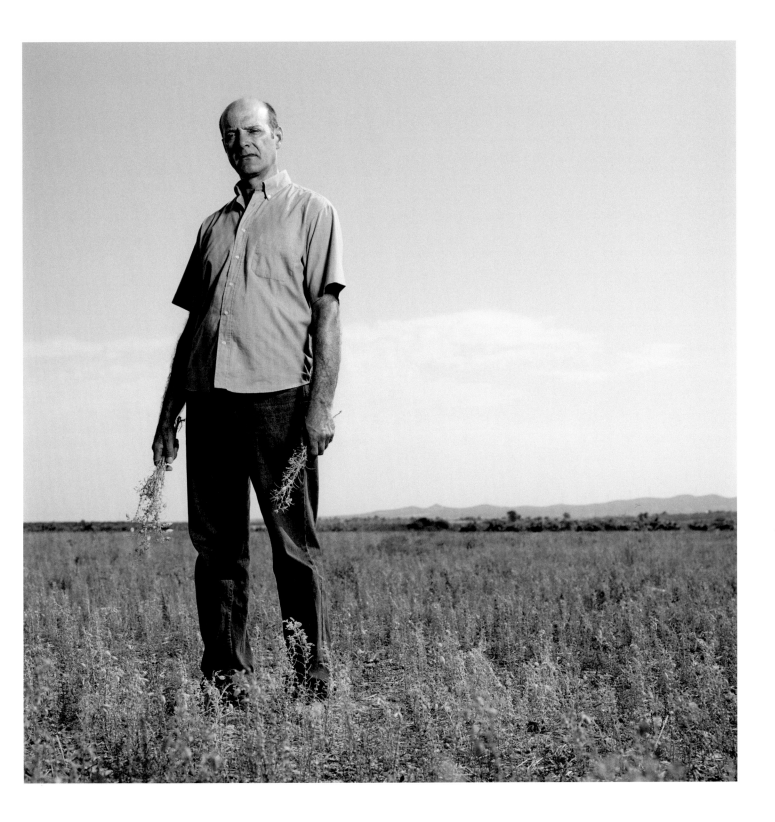

Spain

Miguel A. Torres (68)
President of the Miguel Torres Winery
Vilafranca del Penedès, Barcelona, Spain

We know from our records that in the last forty years the
average temperatures in our vineyard have increased by one
degree Celsius. Heat affects the composition of the grape,
so we have to adapt. The vines we used to plant by the sea,
we now plant at higher altitude in the Central Valley.
And those that we used to grow in the Central Valley have
been moved to the mountain area. Climate change is also
an opportunity for companies that are innovative and prepared
to change. We in the wine business are more affected than
others, so we have to try to change things.

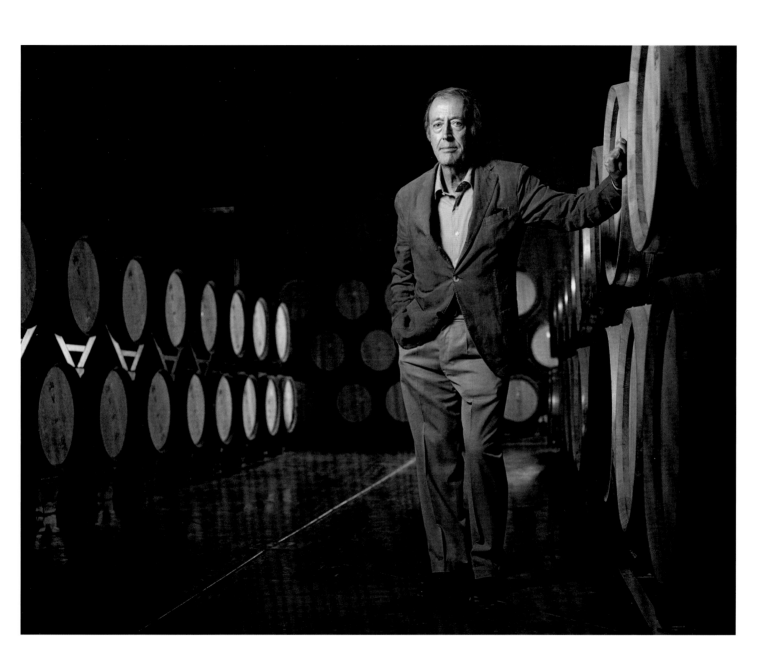

Switzerland

Christian Kaufmann (48)
Shepherd
Grindelwald, Switzerland

The alpine lodge that my grandfather built near a glacier
collapsed down the slope three years ago because so much of
the ice melted. The glacier has lost at least eighty percent
of its volume in the last twenty-five years. That is drastic.
When my grandfather opened the lodge in the 1940s, the
glacier was on almost the same level. But as it started to
retreat, the moraine became unstable and started to collapse,
one piece after another. It was frightening. At one point,
you could see the cleft at the edge of the house, then
everything tumbled down. You can see where the ice was. That
should get us thinking that there is something wrong.

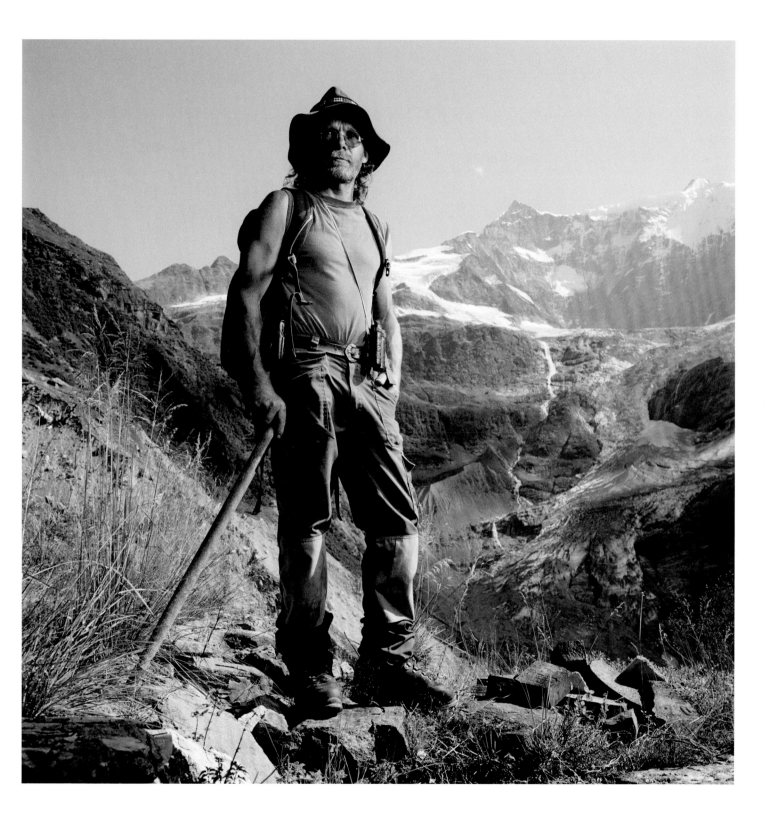

Switzerland

Johann Kaufmann (36)
Mountain guide
Grindelwald, Switzerland

I spent all my childhood here, but a lot has changed. That's a fact. The main change is the shrinking of the glaciers. The Upper Grindelwald Glacier was one of the most famous glaciers in Europe because it came all the way down to the valley, to the forest zone, down to 1,400 meters. But it is retreating and was pushed out of a gorge. That's an extraordinarily visual change. The snow is also melting higher up, above 3,000 meters, in places where it didn't use to when I started mountaineering in the eighties. Then there are these heavy isolated downpours. That is also something that we have never seen before. It is hard to say what the consequences will be for the future, but we will have to learn to deal with these things.

The Upper Grindelwald Glacier is one of the most famous in Europe because it once came all the way down to the valley, but it has been on the retreat since 1987 due to high summer temperatures. The ice fields on the north face of the Eiger are less stable, so climbers face increased dangers from rockfalls in the summer.

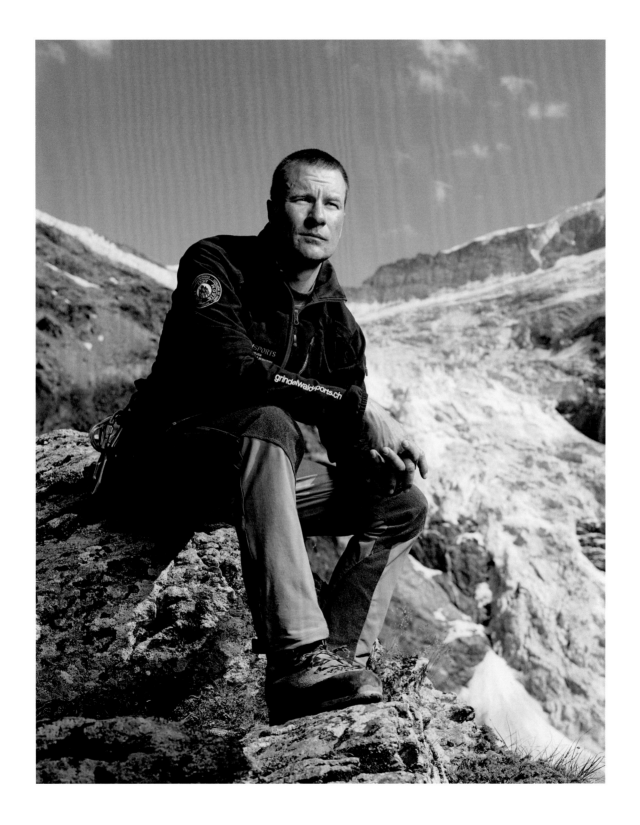

AFRICA

Mali

Chad

Mali

Dogna Fofana (66)
Hunter / Farmer
Dioumara, Mali

We are all going to die. First the animals are going to die,
and then the people. There's not even one drop of water
in the marsh. That's the problem now. It's because the
desert is advancing. Before, the water was everywhere. We
used to fish in the marsh. There were crocodiles; there was
everything in the marsh, absolutely everything. The Bole
River used to be plentiful, but today this river is dry. The
cows don't have enough to eat. I have lost so many animals.
The change is in the rain patterns. Before, in May and June,
rain would come and it would be enough. Now, we have to
wait until July and August. But it's still not enough. As
soon as the rain starts, it stops. Everything is connected.
The wind that blows today is also hotter and more violent
than before. All these effects, according to me and the old
people, are due to the actions of man.

Drought in Chad and Mali is life-threatening. Herdsmen are losing cattle
near Lake Chad, which is shrinking and increasingly polluted. The Bozo
fishermen on the Niger River complain that there is insufficient water,
even to travel by boat any longer. Near Timbuktu the desert creeps
closer to settlements.

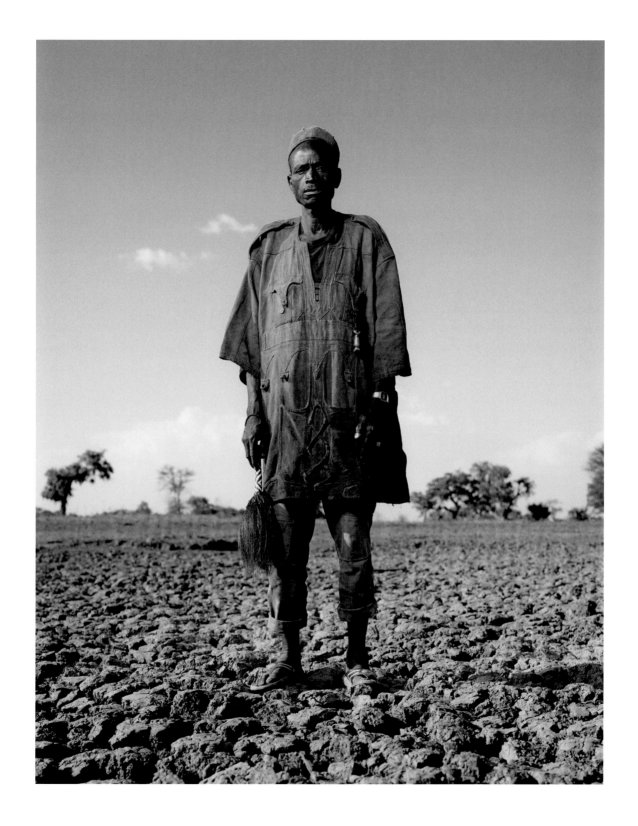

Mali

Gouro Modi (36) with his son, Dao (6)
Cow herdsman
Korientzé, Mali

We are tired, very tired because the climate has changed.
Our homes are far from here. We left because there was not
enough rain. We follow the pastures. We go where there is
water. It used to rain a lot, but not now. When I was a child,
the animals ate well, the people ate well, and everything
went well. But, there's been a really big change. I'm afraid.
All the breeders and shepherds are afraid. If there's no
water, we will actually have to dig so that the cows can find
water to drink. Our hope is that the water doesn't disappear
right away. We pray for the water to come so that the
animals can find food to eat.

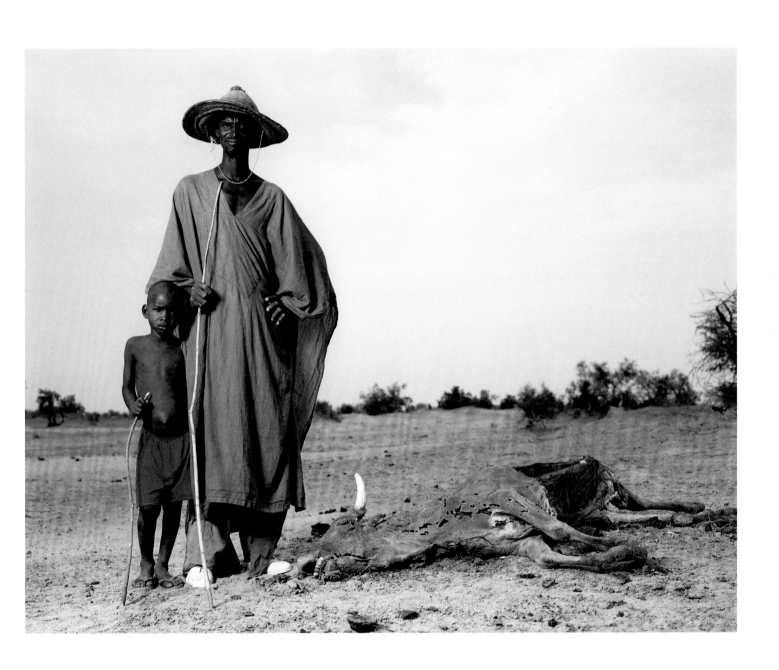

Mali

Haawo Mahamman (53)
Leader of the women's association
Toya, Mali

My fears in life are linked to water scarcity and desert
advancement. In the past, there was a lot of rain and there
were no problems. But now, it does not rain anymore and this
is what makes the sand advance very fast. Before, we could
not cross this river on foot; but today people don't need a
boat to get to the other side because the sand has swallowed
the river. Some months ago, we had to move our vegetable
gardens because they were consumed by sand. It has eaten all
the papayas we planted and we are now scared the same will
happen to our homes. None of the things that have been tried
have really worked, because the sand closes in on everything,
and the water from the Niger is getting lower and lower. This
scares me too much. In the end it is death.

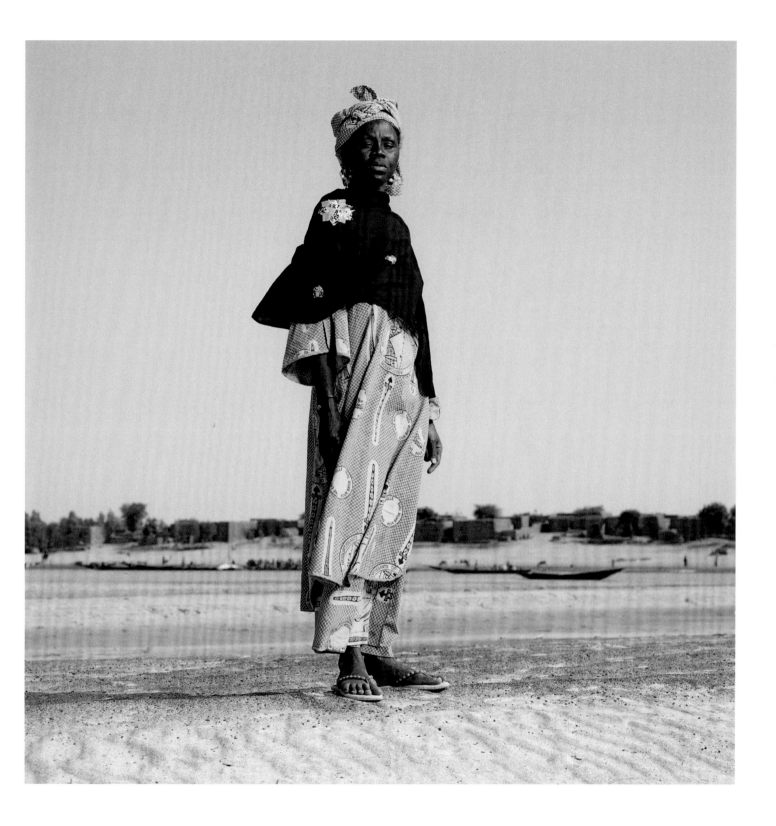

Mali

Mama Saranyro (59)
Member of the nomadic Bozo tribe / Fisherman
Salamandaga, Lac Korientzé, Mali

Our crisis is caused by a lack of water. Bozo are traditionally
nomadic fishermen. We travel by boat. But now there is
neither enough water nor enough fish. Our boats are stuck in
the dried-up river. Since 2003, water levels have diminished
along with the rainfall. In the past, we would not have
been able to sit here because it would be covered by water,
but now there is nothing. We have tried collective fishing
and putting aside stretches of river as a reserve for fish to
breed, but fishing is no longer profitable. If things remain
like this for the next ten years and if we do not get any
assistance to change our way of living, we are going to suffer
a lot.

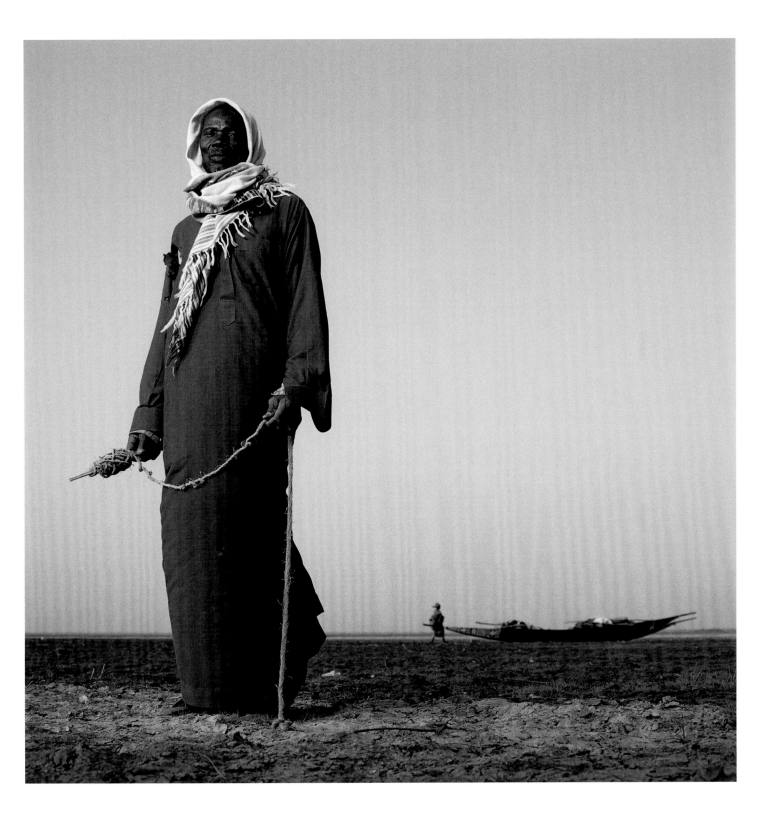

Mali

Makan Diarisso Congo (54)
Farmer
Bema, Mali

I have always loved this place, but recently there has been
a big change because we are not getting the water we need.
This has made me think a lot about the future. The weather
has changed quite noticeably. It rains less than a twentieth
of the amount in the past. We have to dig to get water now.
This was not the case when I was a child. Then we had a lot
of rain and good marshes. The water was there all year round.
People and cows could drink from it. The trees used to hold
the sand at bay. But now the trees are gone, so the advancing
desert enters the watering hole, and bit by bit the water
level has diminished. For seven months of the year, we cannot
get enough water for ourselves and our cows. This has brought
big difficulties for our village.

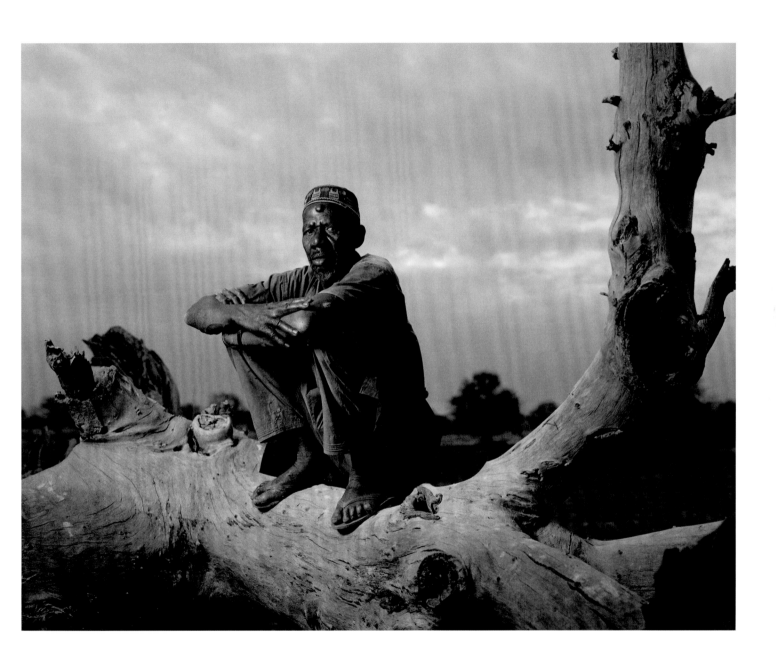

Mali

Ahmad ag Abdoulahy (67)
Touareg / Herdsman
Tirikene, Timbuktu, Mali

This is not the same Earth I knew in the past. Everything is different. The Earth, nature, and animals were more beautiful than they are today. The climate has changed quite a bit. We only receive a third of the rain we're used to. In the past, after the first rain, within two to three weeks the animals would have enough grass. But now there are years when it doesn't rain at all and even when it does, there are no seeds because the animals eat them before they have time to grow. I worry about my family and my grandchildren. If there's not enough grass, then there's not enough milk. Without milk, we don't have enough nutrition.

I'm starting a new life. In the past, I just I woke up, took my stick, and accompanied my animals to the pastures. That was all the work I knew. Today, most of my activities are not activities that I really know. I will go towards modern life: schools, construction, work as a day laborer. I pray night and day that a change will come to this great dryness, this lack of rain, and this great heat; that we will find ourselves again in our past life, how we were before.

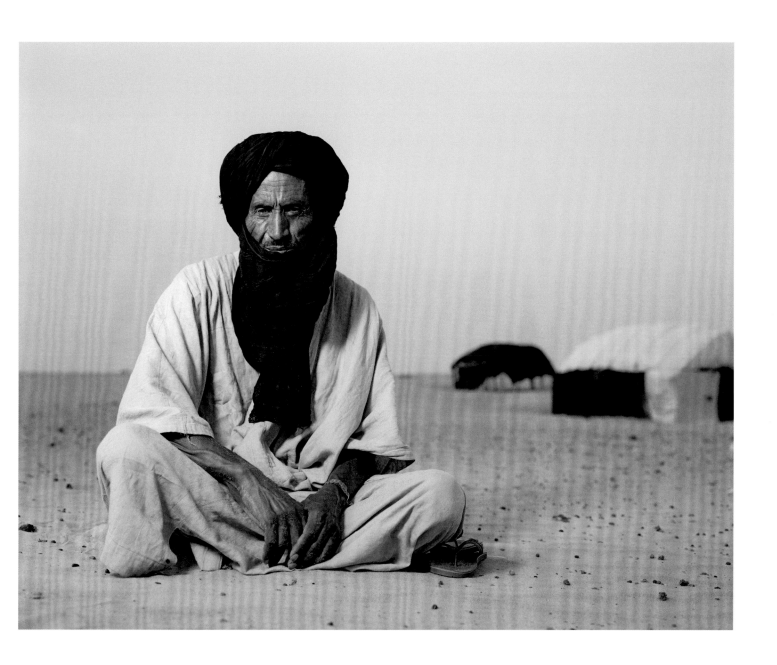

Mali

Soumbou Bary (25)
Member of the Peul minority
Ngnamerourè, Mali

I'm scared because I do not have anything to give to the children. Neither my family nor I have the means to do anything. This frightens me. For me, these changes have happened because the water and the rain don't come as they did before. We don't have anything to eat and it is very hot. This started changing at least ten years ago. Now, even if the rain comes, it is not enough. The weather has really changed.

After this, it is death that follows. It is not the same thing as when I was a child. The weather then was very good, the rain and the animals were fine, and everybody ate well. The weather is not as before; because now there is nothing, there is nothing for us to eat, nothing for the animals to eat, nothing to do. We are really tired.

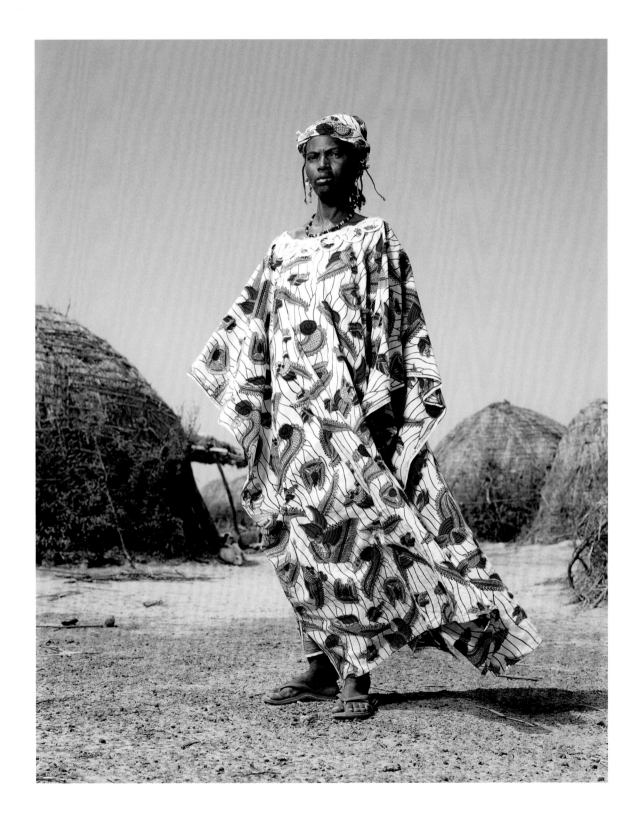

Mali

Maimou Toumani (40)
Bozo / Leader of the women's association
Koriomé, Mali

We live on the shores of the Niger. We used to have to move
seven kilometers when the waters rose high, but there is not
as much water in the river today. In the past, we could not
have sat here. When I was a child we used to fish here. It
only took a couple of hours then we could go home. The weather
was nice. But there has been a big change. There is no longer
as much rain as there used to be. We don't eat as we used
to. If before we ate two kilograms, now we only eat one.

My husband is a fisherman, but there are no more fish, so
we have to cultivate vegetables. We created a women's
association and took out a micro-credit loan to start it. The
vegetable gardens gave us enough to eat. But we have stopped
cultivating them because it got hotter in the past ten years
and there is not enough water. We made irrigation ditches
and dug a well, but this is very, very hard. One day in the
past was worth what a year is worth today. This has made us
very tired. I hope this climate change does not continue. If
the heat gets worse and the fatigue gets worse then everyone
will die, the whole village will die.

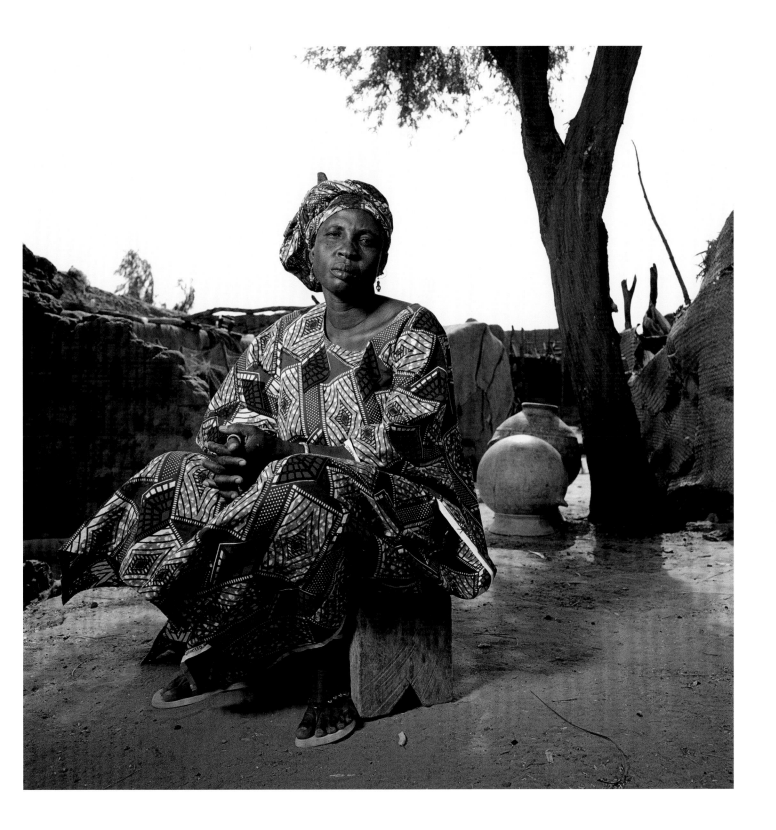

Chad

Fatama Djapraul Mousa (25) and her children,
Ruca (7 months), Koundoum (7), and Omer (3)
Farmer
Karala, Chad

Three of my six children have died of diarrhea. The first
one was seven months old, the second six months, and the
third three months. It is very difficult for me. When the
weather is too hot, and there is no more water, the farmers
are unable to produce enough food to eat. That's why I had
problems with my three babies that died. They died because
the water is bad. Our neighbors' children also have problems.
They became so sick they had to go to the hospital. The water
used to be absolutely good. You could drink it anytime, no
problem. But in the past six years, the rainy season comes
much too late. That is very bad for us.

When I was young the lake was only about five kilometers
from here. But now you have to walk more than fifteen
kilometers. The water here is polluted. There's something in
it that makes the kids sick. It is too hot to be here. Now,
my little daughter has become sick, too. It is from the
heat. Sometimes she has problems with diarrhea and has sores
on her skin from the sun. When I was young everything was
good for us. But now the weather has changed a lot. Our life
has totally changed.

With declining rainfall, water availability has become a major problem
in Chad. People drink from any pool they can find, even though it is
sometimes of very poor quality.

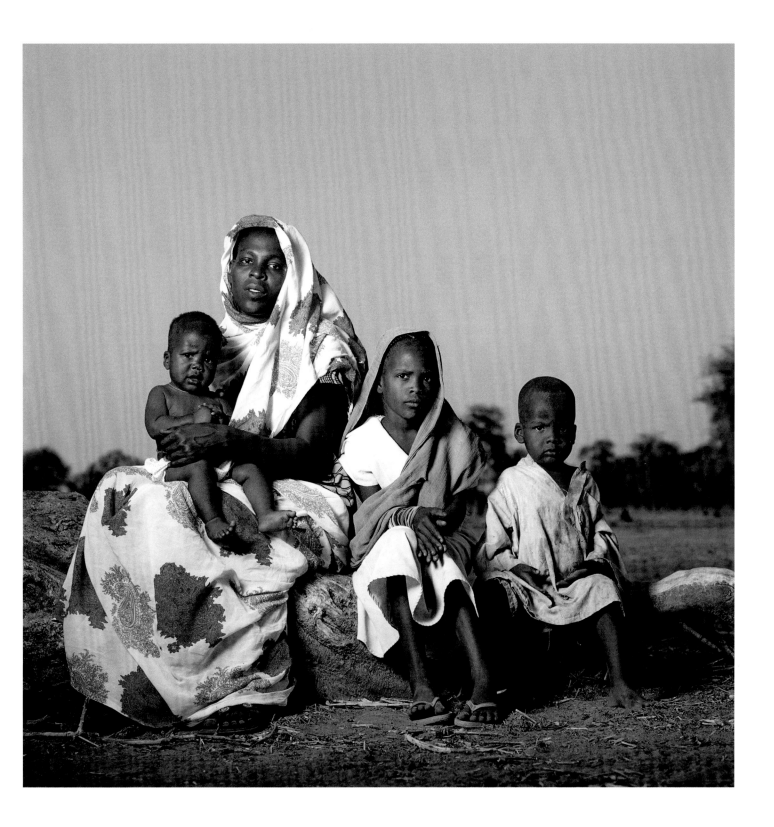

Chad

Hassin Abakar Khoraj (69)
Farmer / Village elder
Alibeit, Chad

Life is not as it used to be when I was young. In the past twenty years, everything has changed. It is too hot now. Our children are getting sick and are dying. They get diarrhea and blisters. In the past the rainy season lasted from June until September. Now it comes only in July and August. This village used to be called "Al Obir," which means "something white," because of its flood waters. But now we don't have enough water, we don't have enough food for our children. Most people have moved. There are only seventy-five people left in the village. Two hundred have gone. If the situation with the weather doesn't change, more and more people will leave.

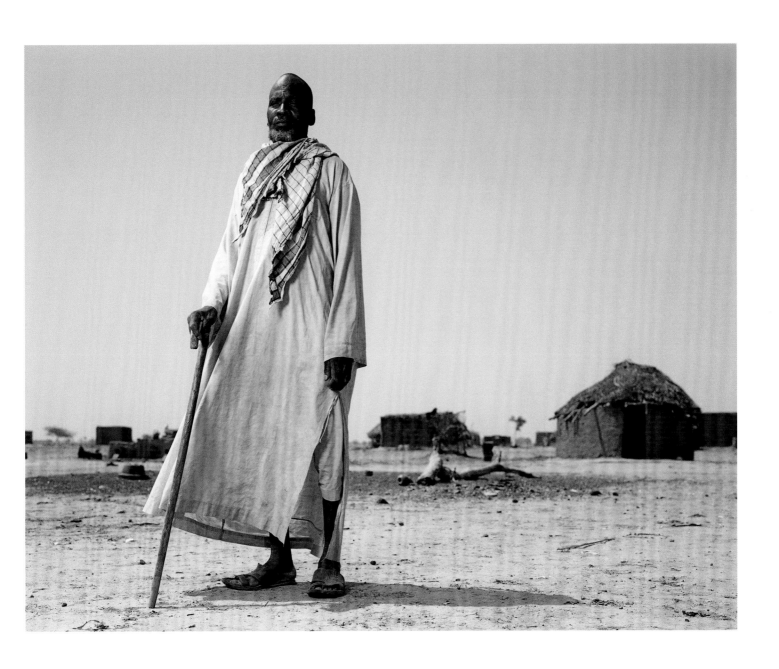

Chad

Abakar Maydocou Mahamat (59)
Farmer / Former fisherman
Maydocou, Lake Chad, Chad

I have two wives and ten children. But I can't really take
care of them. There are no more fish. There is no water. The
rainy season is late and we can't work on our fields. It
takes three hours to walk to the lake from here. Before it
took just one hour. So I stopped being a fisherman and
became a farmer. But it's difficult to work as a farmer now.
There is no more grass for the cows. The drinking water is
really bad here. It can kill you. Everything has changed. We
are all tired of this situation, but there is nowhere else
to go. We just hope that the future for our children will be
better, that they will have a better life here.

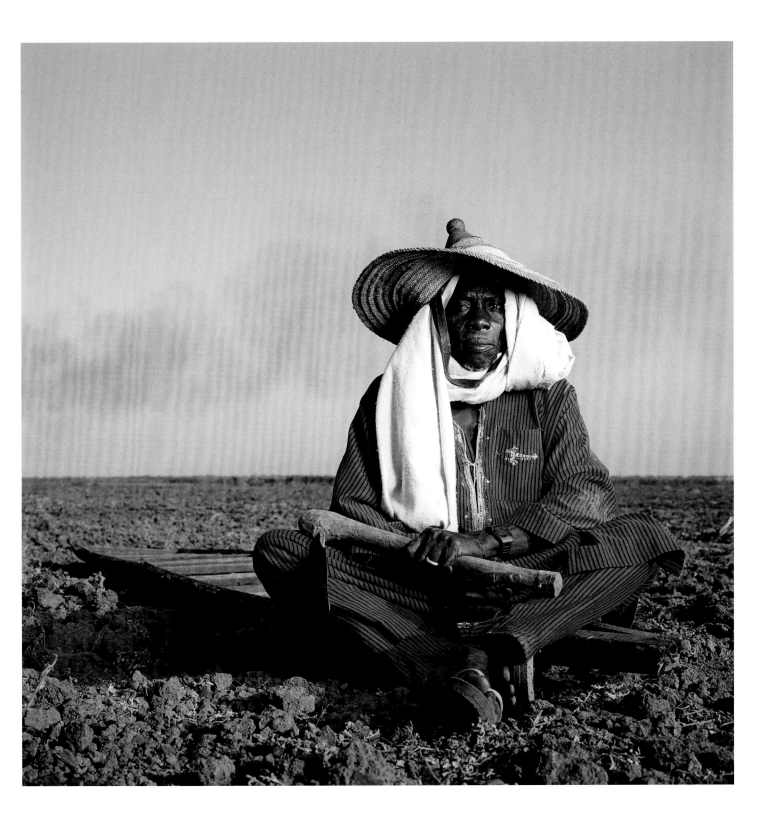

Chad

Abdallay Abdou Hassin (54)
Cow herdsman
Mayara, Lake Chad, Chad

I think it's the end of the world. Up until fifteen or
twenty years ago we had a good life. The rainy season came
and the land was good. But since then the situation has
become worse and worse. There is not enough rain. I left my
village because there was not enough water. I came here
because this place is close to the lake. But the cows are
getting sick. In the last couple of years there is not enough
rain and the water quality is bad. I used to have thirty
cows, but fifteen died because of these problems. When I was
a child, we were happy, we had a lot of milk, we had clean
water, and we ate good food. The trees were lovely and
green, not like today. Now it is really bad. Everything has
changed.

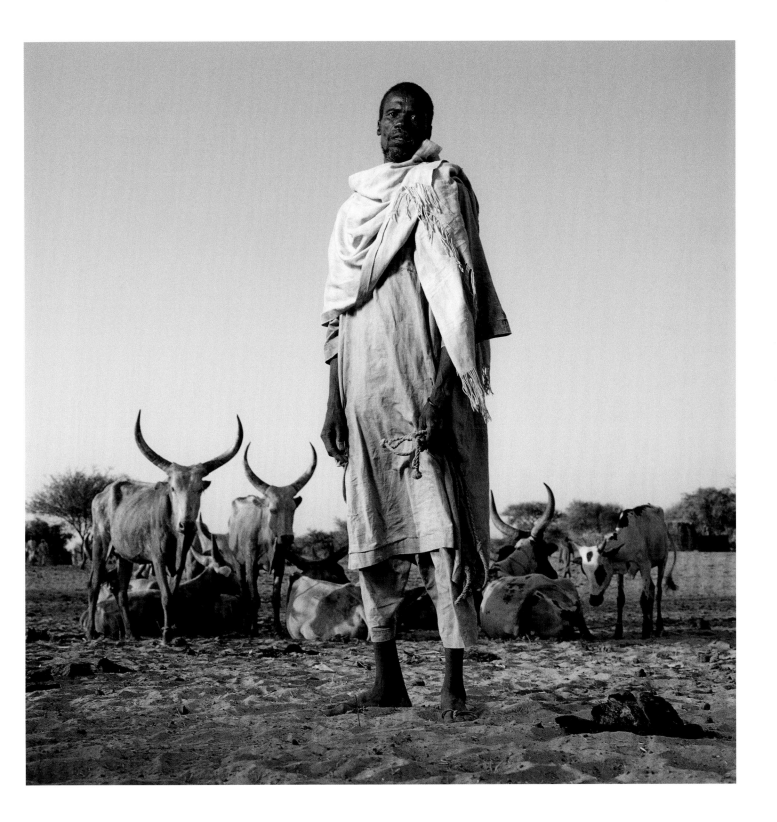

Mathias Braschler was born in Aargau, Switzerland, in 1969. He studied geography and modern history at the University of Zurich for two years, before beginning his career in photography as an autodidact in 1994. He worked for various magazines and newspapers in Switzerland before moving to New York in 1998, where he published his first book, *Madison Avenue* (1999). In the following years he lived and worked in New York.

Monika Fischer was born in St. Gallen's Rhine Valley in Switzerland in 1971. While studying Romance languages and German at the University of Zurich, she also began working as a dramaturge and director's assistant at the opera house in Zurich. Over several years she worked with very important directors. Besides her successful collaboration with Mathias Braschler, Monika Fischer completed a postgraduate degree in scenography at the Zurich University of the Arts between 2003 and 2005.

In 2003 Mathias Braschler and Monika Fischer began working closely together as a photography team, producing a portrait project that was published as *About Americans* (2007), which took the two of them all over the United States. In 2005–06 they worked on the *Faces of Football* project. With idealistic support from FIFA, they photographed thirty soccer stars immediately after important games. One year before the Beijing 2008 Olympic Games, Braschler and Fischer began a seven-month-long epic journey through China. On their 30,000-kilometer road trip they shot portraits of Chinese people from diverse social classes throughout this immense nation full of rich contrasts. In 2009 they realized an acclaimed photo series about people who are directly affected by climate change.

Braschler & Fischer have won many awards for their works, including a World Press Photo Award and an ADC Bronze Award in Germany. Their photography projects are published in countless international magazines, appear in photo books, and are exhibited in galleries and museums in Europe, Asia, and the United States.

Today Mathias Braschler and Monika Fischer divide their time between New York, where they are represented by Vaughan Hannigan, and Zurich.

Acknowledgments

This research and travel-intensive project would not have been possible without the support of innumerable people and organizations.

First of all, we would love to thank Jonathan Watts for being a great travel companion in Thailand, Siberia, and China; for being willing to go through hundreds of pages of interview transcripts; and for writing the text elements for this book.

We owe special thanks to the Global Humanitarian Forum, Kofi Annan's Geneva-based international non-profit organization, especially to Walter Fust and Martin Frick; and to the Volkart Foundation, Judith Forster, Andreas Reinhart, and Marc Reinhart. Only thanks to their moral and financial support we were able to realize our project on such a global level.

Our thanks also go to Jenny Clad and Roy Neel. The collaboration with Al Gore's The Climate Project was a great enrichment.

We extend a thousand thanks to Paul Merki and Light + Byte AG, for sponsoring us by providing free access for the scanning of our negatives.

We are indebted to Lea Meienberg, who worked long hours as our assistant in Zurich.

Creating transcripts and translations from thousands of minutes of video interviews was an enormous task. We owe Ignacio de las Cuevas, Anna Zongollowicz, and Marlyne Sahakian our deepest respect.

Among the numerous airlines with which we flew to visit all our destinations, Singapore Airlines and Emirates were outstandingly helpful when we had to book complicated flight combinations and very generous with transporting our heavy equipment.

We also wish to thank the following people and organizations who helped us by providing information on the scientific background and practical details for the different countries: Hans Herren from the Millennium Institute; Mim Lowe, TCP Australia; Sean Lee, Mt. Real in Healesville; Emeretta Cross, Norman Cross, Emil Schutz, and former President Teburoro Tito in Kiribati; Alejandro Argumedo, Katrina Quisumbing King, and Kike from the Asociación Andes in Cusco, Peru; Mohon Kumar Mondal from LEDARS, M. Anisul Islam and Tapas Ranjan Chakraborty of CNRS, Masood Hasan Siddiqui and Mohammed Manjur Hossain of SDRC in Bangladesh; Gernot Laganda, Regional Technical Advisor Climate Change, Angus Mackay and Doungjun Roongruang, aka Moon, UNDP in Thailand, Ravi Agarwal, TCP India, Caroline Borchard, UNDP India, Chewang Norphel the Ice Man, Leh Nutrition Project, Padma Tashi, Rural Development & You, and Tenzin Wangdus in Ladakh, India; Dr. Mikhail N. Grigoriev, Permafrost Institute Yakutsk, Sascha, our Russian and Yakut Interpreter in Siberia; Barbara Lüthi and Tomas Etzler and Jonathan's assistant, Tori, in China; Arturo Caponero, ALSIA—Area Sviluppo Agricolo, Legambiente, Bartolomeo Dichio, Department of Crop Systems, Forestry, and Environmental Sciences, University of Basilicata, and Emanuele Scalcione, Agrometeorologic Service Lucano, in Basilicata, Italy, Miguel Torres, Spain; Johann Kaufmann, Grindelwald Tourism and Sports, and Christian and Pablo Kaufmann, who helped carry dozens of kilos of equipment up the Alps to the diminishing glacier of Grindelwald, Switzerland; Sonia Rolley in Chad; Mahmoud Diallo, our passionate driver and interpreter in Mali, Moussa Dagnon, Forest and Environment Guard at Lake Korientzé, Esther Amberg and Franck Merceron from Helvetas, Mali; Ed Pilkington, author for the Guardian, and Grant Kashatok, School Principal, Newtok; Doug Bennett, Conservation Manager of the Southern Nevada Water Authority, Las Vegas, United States; Silvia Rodriguez and Yusnovil and Mauricio Alonso in Havana, Cuba; Sarah Lustenberger, Emirates Zürich; Wilson Favre-Delerue from the Global Humanitarian Forum, Geneva; Fiorenza, Simon, Letisha, and Sean for looking after Gobi and Taishan; Reto Knutti, professor of the Institute of Atmospheric and Climate Science, ETH Zurich; and many more, especially to the countless authors of all the scientific literature that was fundamental to our research for this project.

Stern, *The Guardian Magazine*, and *Vanity Fair* Italy are always the first to believe in our ideas and were again wonderful partners. We are grateful to Andrea Gothe, Kate Edwards, Marco Finazzi, and Daniele Bresciani.

We are most honored to have been nominated for the Hall of Fame of Vanity Fair USA, and extend our warmest thanks to Susan White and David Friend.

Many thanks to Peter Zimmermann for his creativity and experience in designing this book and for many hours of great, productive exchange. Special thanks also go to the team of Hatje Cantz, especially to Markus Hartmann, Tas Skorupa, Joann Skrypzak, Uta Hasekamp, and Ines Sutter.

What would we be without the invaluable support of our parents? Only thanks to Elisabeth and Alex Fischer and Heidi and Alex Braschler are we able to live, work, and travel for our passion and ideas. We feel very lucky to be surrounded by the best of families and friends.

But we owe our deepest gratitude to all the people in our portraits. They opened their homes and hearts to show us their lives and tell us about their experiences.

Mathias Braschler & Monika Fischer

This project has been supported by the Volkart Foundation and Swiss Re.

VOLKART STIFTUNG

Swiss Re
Ⅲ

Copyediting: Joann Skrypzak
Graphic design and typesetting: Peter Zimmermann
Typeface: Univers and Courier
Production: Ines Sutter, Hatje Cantz
Reproductions: Repromayer GmbH, Reutlingen
Printing: appl druck GmbH & Co. KG, Wemding
Paper: Condat matt Périgord, 150 g/m²
Binding: Conzella Verlagsbuchbinderei, Urban Meister
GmbH, Aschheim-Dornach

Published by
Hatje Cantz Verlag
Zeppelinstrasse 32
73760 Ostfildern
Germany
Tel. +49 711 4405-200
Fax +49 711 4405-220
www.hatjecantz.com

Hatje Cantz books are available internationally at selected bookstores. For more information about our distribution partners,
please visit our website at www.hatjecantz.com.

ISBN 978-3-7757-2807-2 (English)
ISBN 978-3-7757-2806-5 (German)

Printed in Germany

Cover image: *Mama Saranyro (59). Member of the nomadic Bozo tribe / Fisherman.*
Salamandaga, Lac Korientzé, Mali (see pages 124–25)